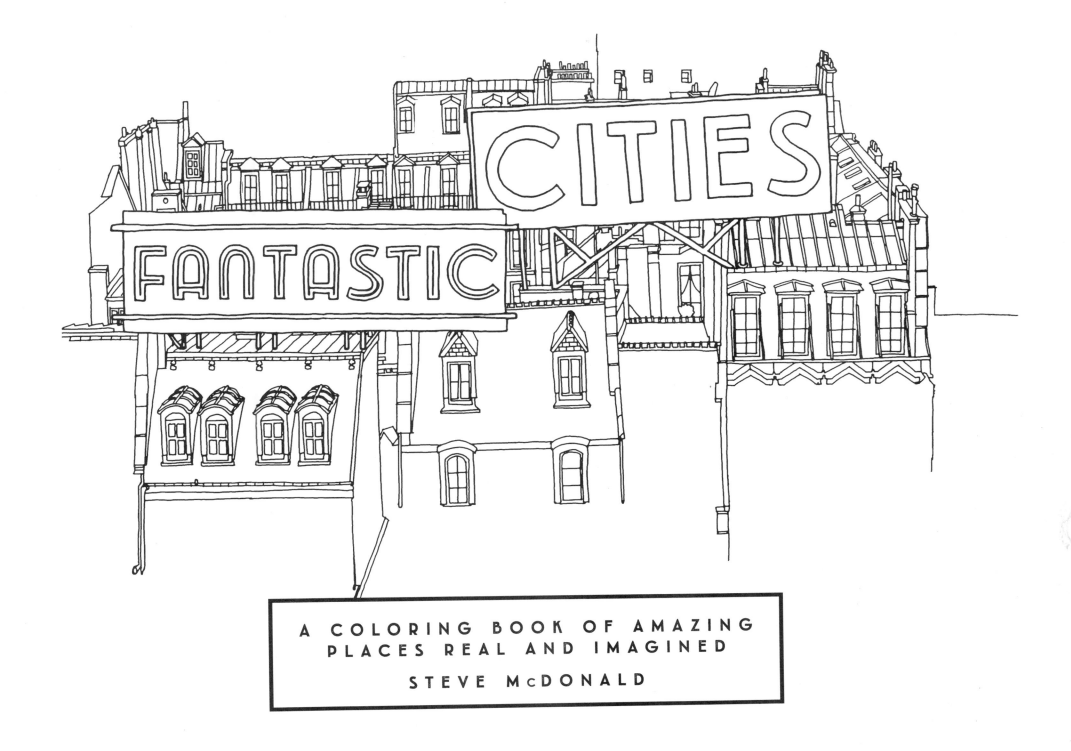

FANTASTIC CITIES

A COLORING BOOK OF AMAZING
PLACES REAL AND IMAGINED

STEVE McDONALD

CHRONICLE BOOKS
SAN FRANCISCO

This book is dedicated to my daughters Roxana and Asha—
for allowing me to see the world through fresh eyes.

Although many of the images have been drawn from my own photographic sources, I want to also acknowledge and thank the following photographers for the wonderful images used in part for some of the drawings: **David Buckett** (Ladakh); **Steve F-E-Cameron** (Oliver's Wharf); **Chensiyuan** (Rocinha Favela; Singapore); **Bernard Gagnon** (Himeji Castle); **Jialiang Gao** (Shibam); **Henry Hemming** (Central Park West); **Carmen Henesy** (San Francisco Hillside Houses); **Garth C. Huxley** (Sunset on Santorini); **David Iliff** (Piccadilly Circus); **Edwin Lee** (Strasbourg); **Klaus Leidorf** (Donauwörth; Factory Rooftops; Wasserburg); **J Lian** (Habitat 67); **JPhilipG** (SoHo); **Alex S. MacLean** (Bremen; San Francisco from Above); **Akeil Merchant** (Guadalajara); **Neil Paton** (Newtown Post Office); **Rebecca Plotnick** (Paris); **Sopasnor** (1st Avenue and East 60th Street).

ISBN: 978-1-4521-4957-8
Manufactured in China

MIX
Paper from
responsible sources
FSC™ C104723

Illustrations by Steve McDonald
Designed by Ben Kither and Neil Egan

10 9 8 7 6 5

Chronicle Books LLC
680 Second Street
San Francisco, CA 94107
www.chroniclebooks.com

Chronicle books and gifts are available at special quantity discounts to corporations, professional associations, literacy programs, and other organizations. For details and discount information, please contact our premiums department at **corporatesales@chroniclebooks.com** or at 1-800-759-0190.

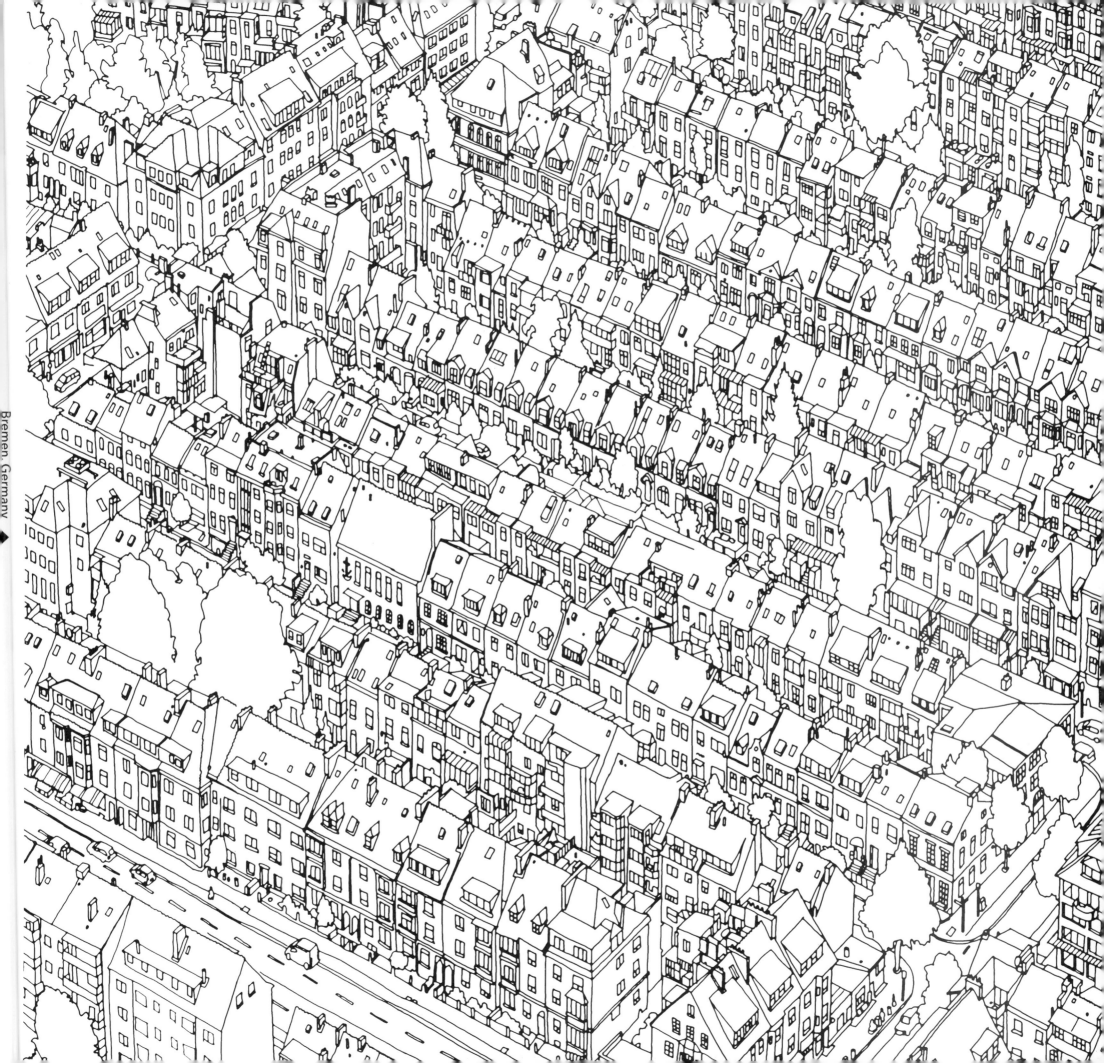

Bremen, Germany

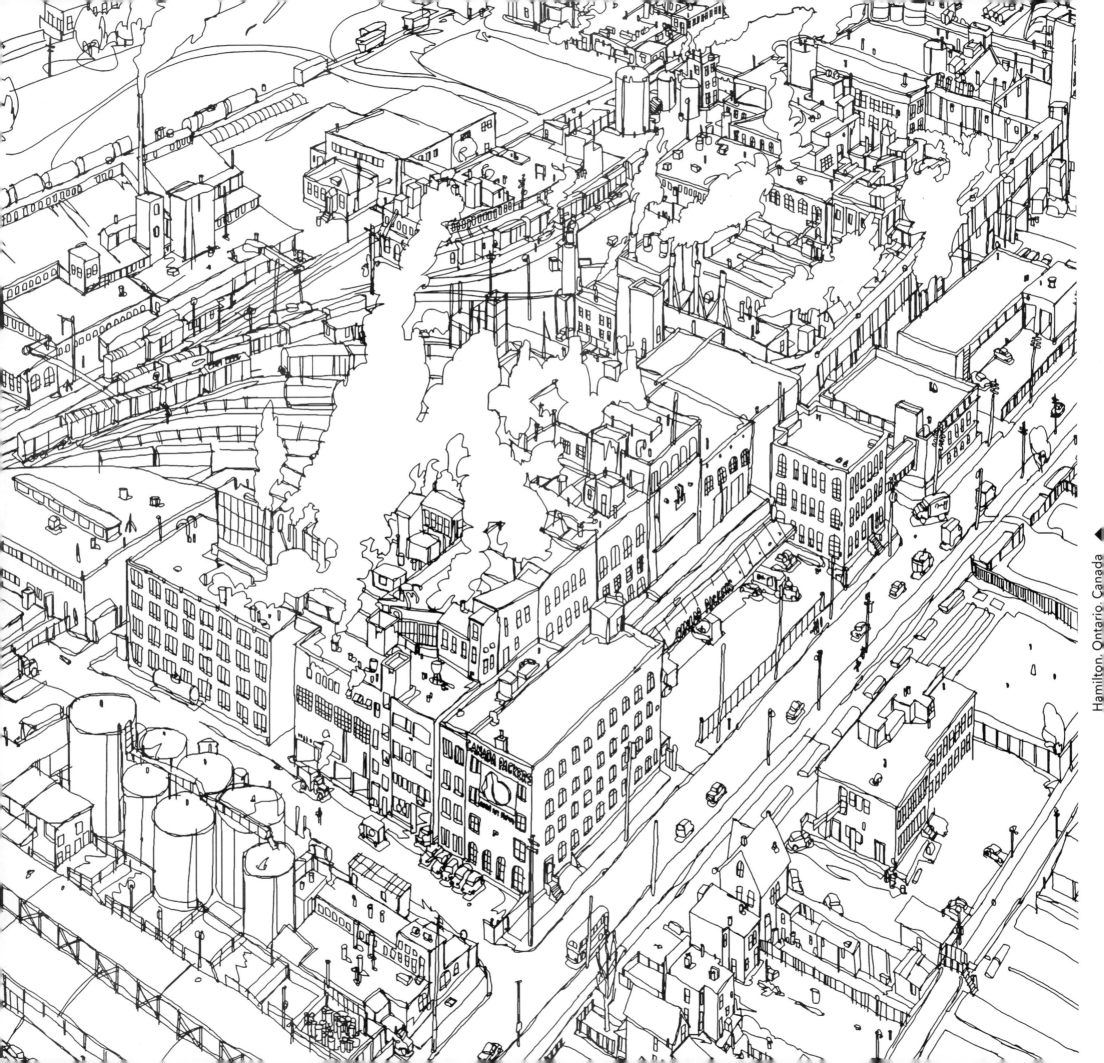

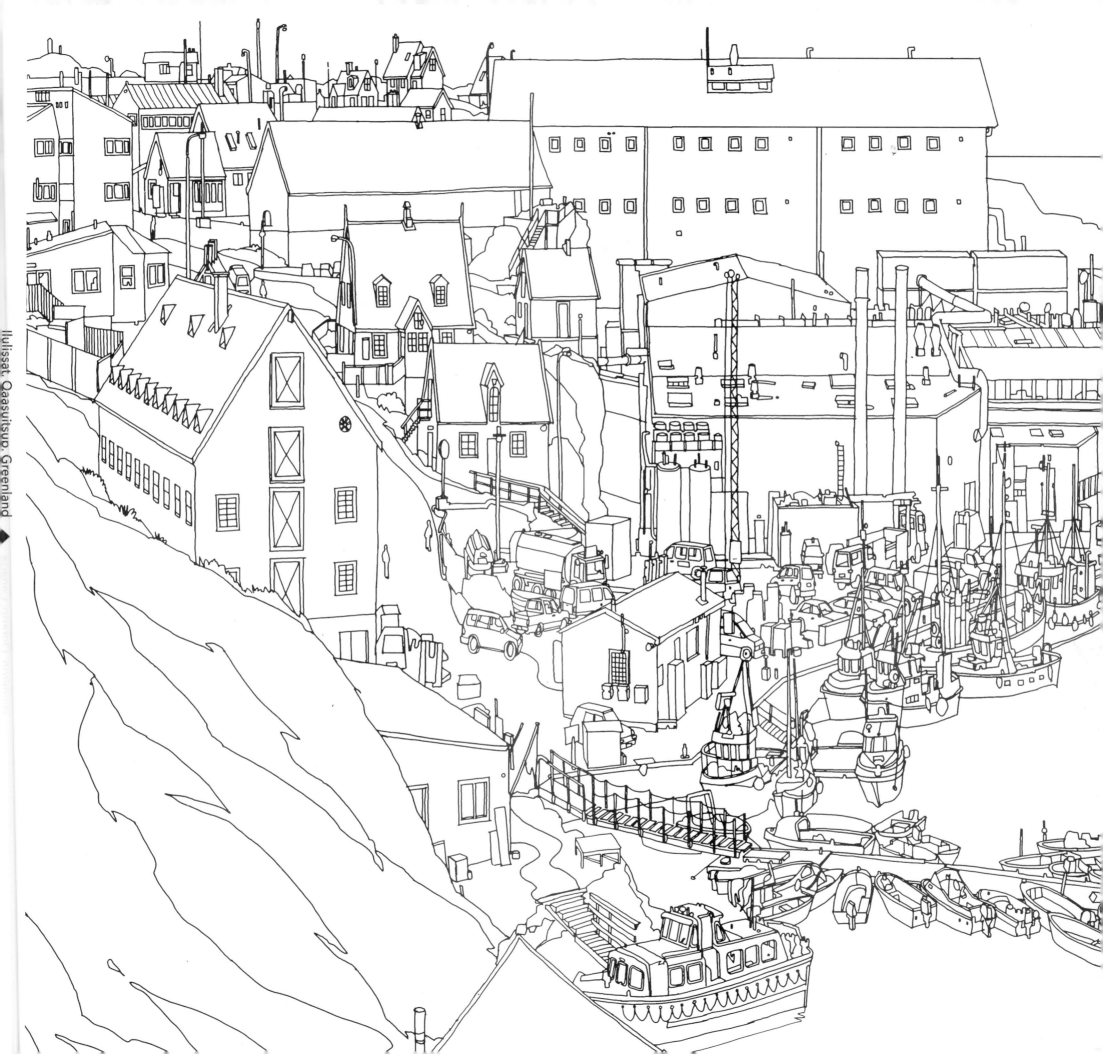

Ilulissat, Qaasuitsup, Greenland

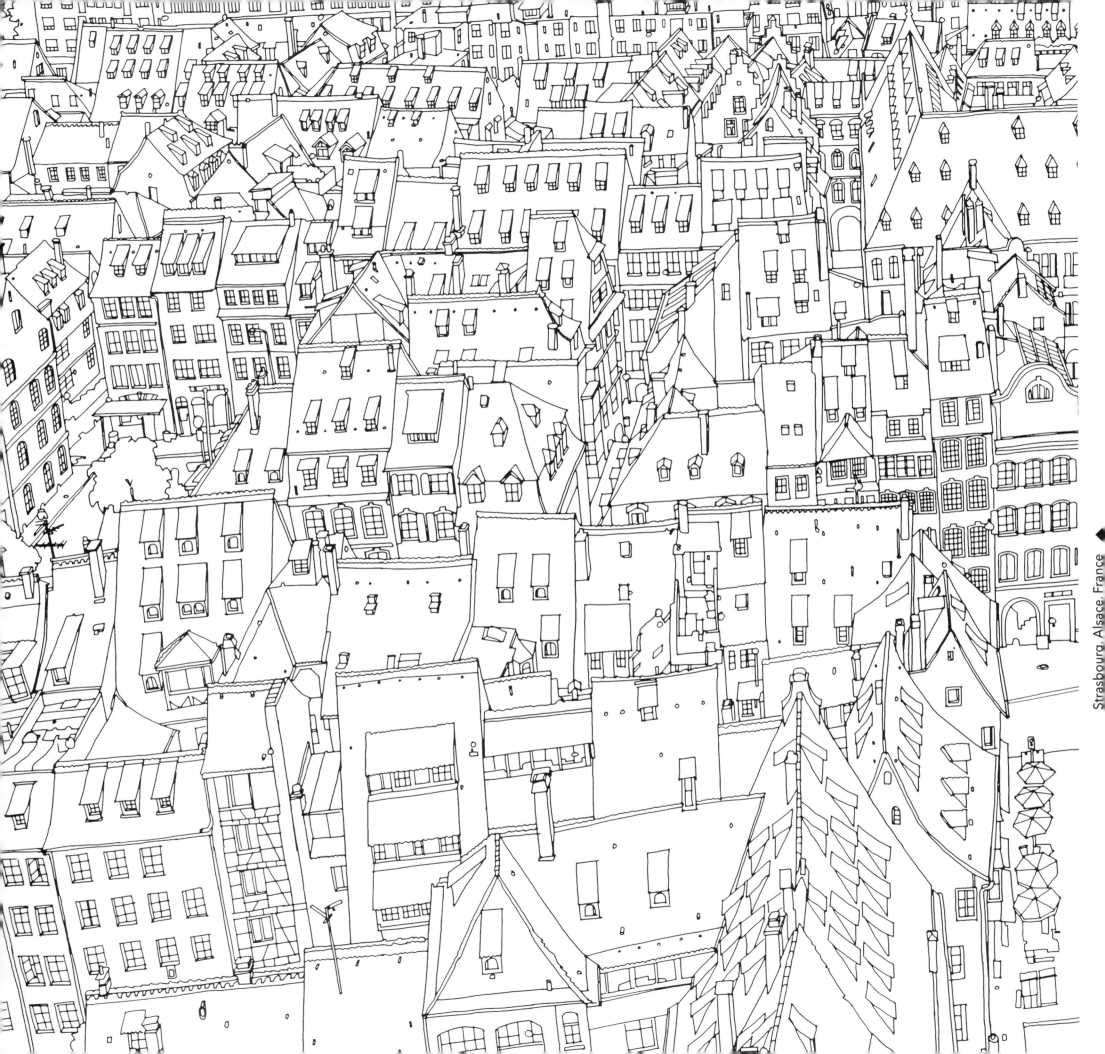

Strasbourg, Alsace, France

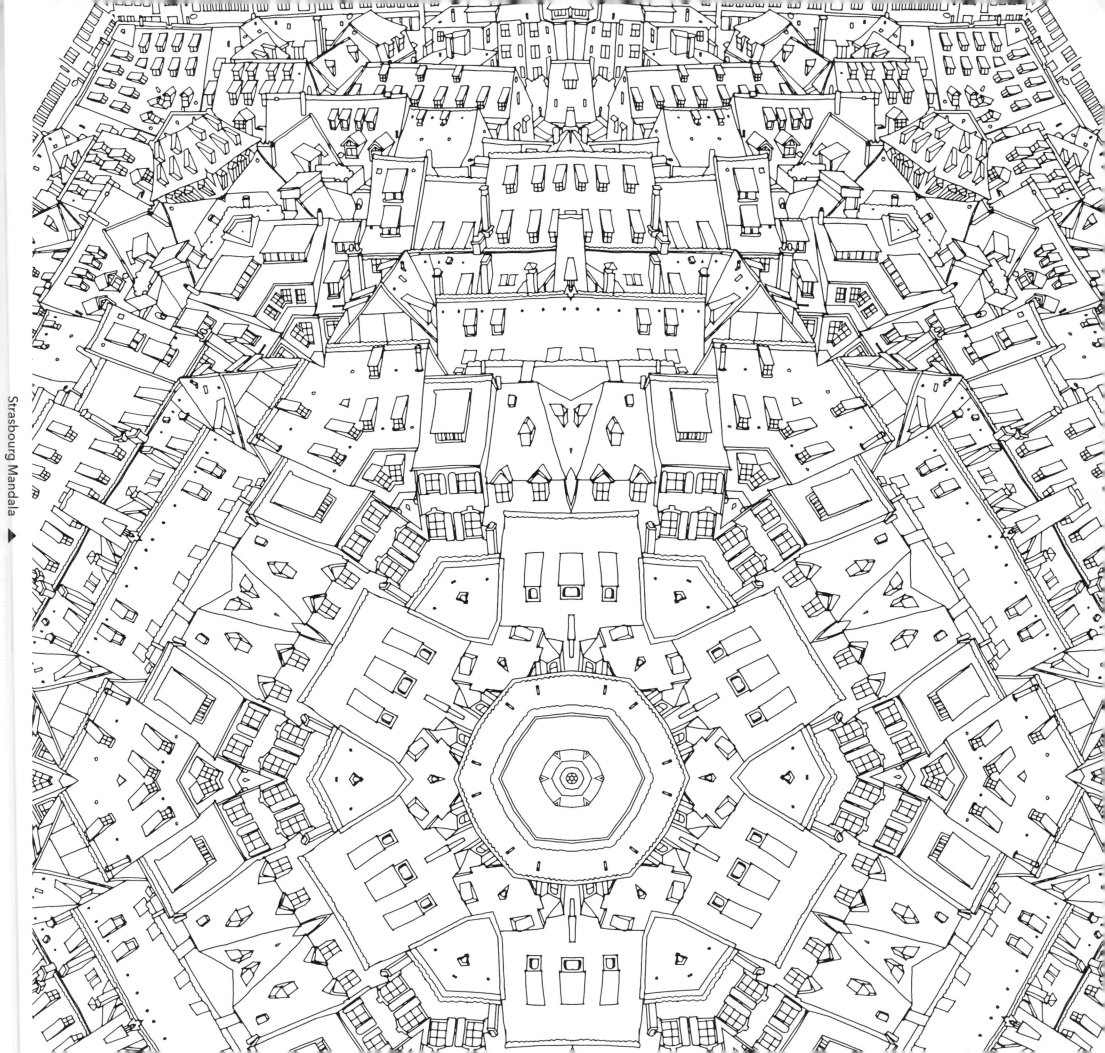

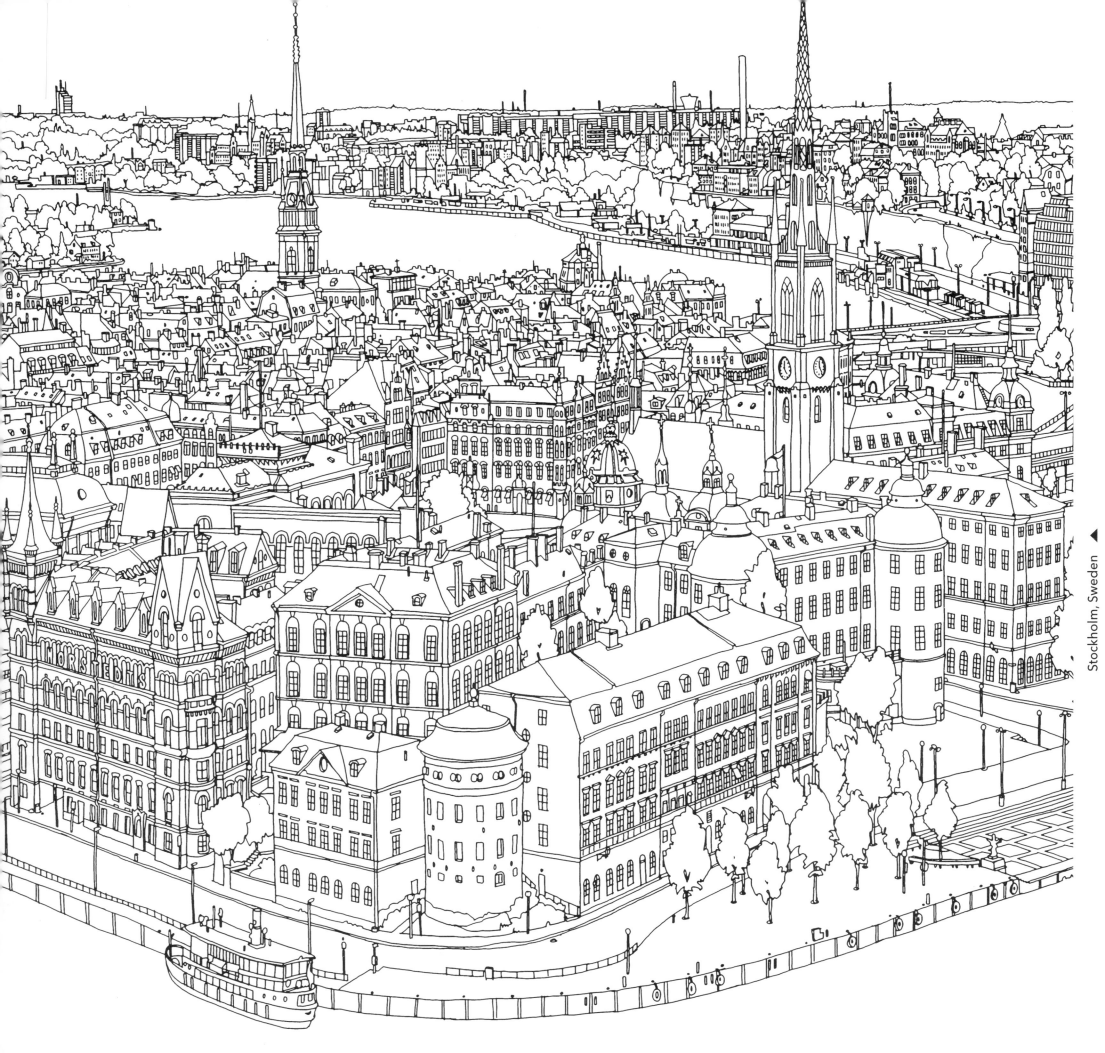

Stockholm, Sweden ◄

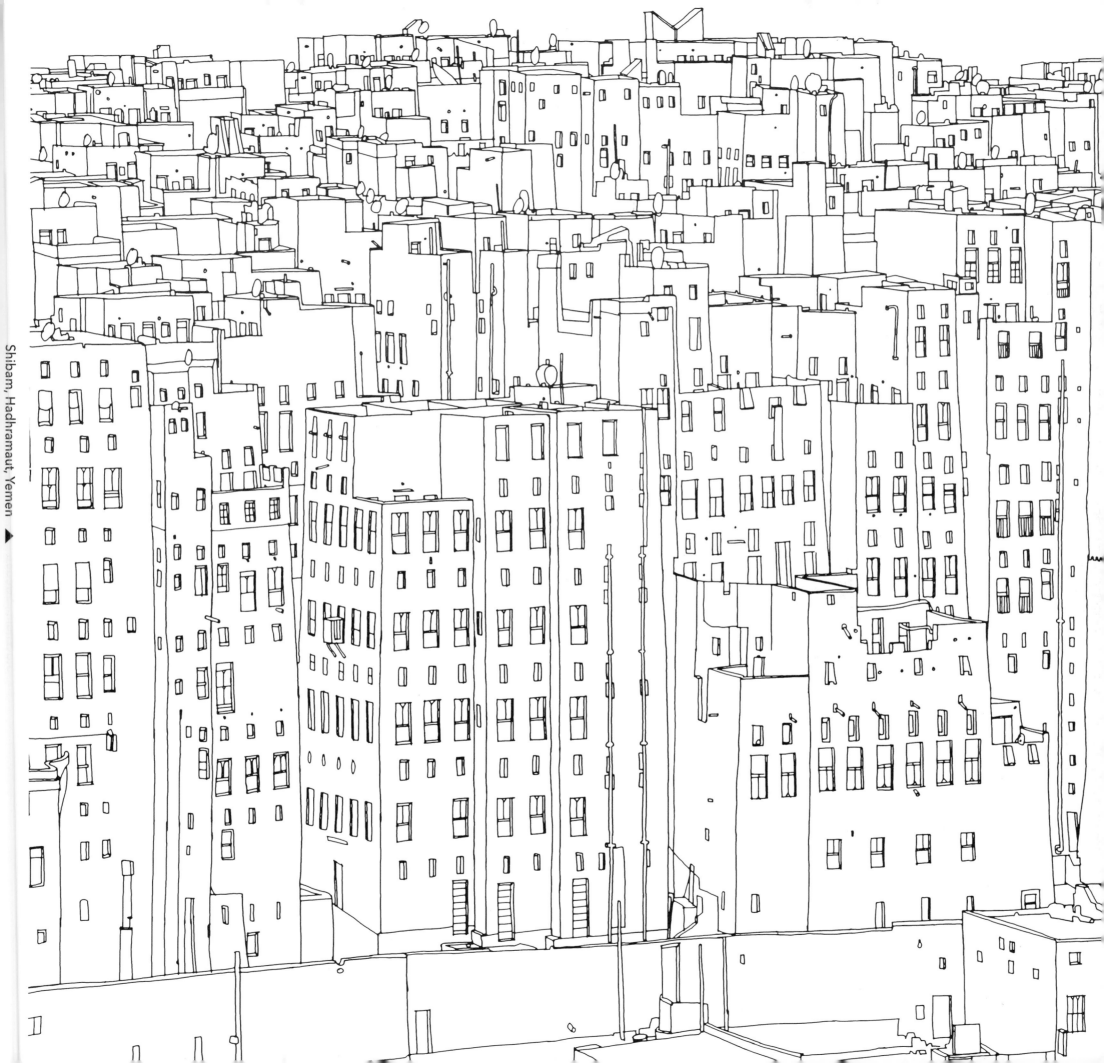

Shibam, Hadhramaut, Yemen ▲

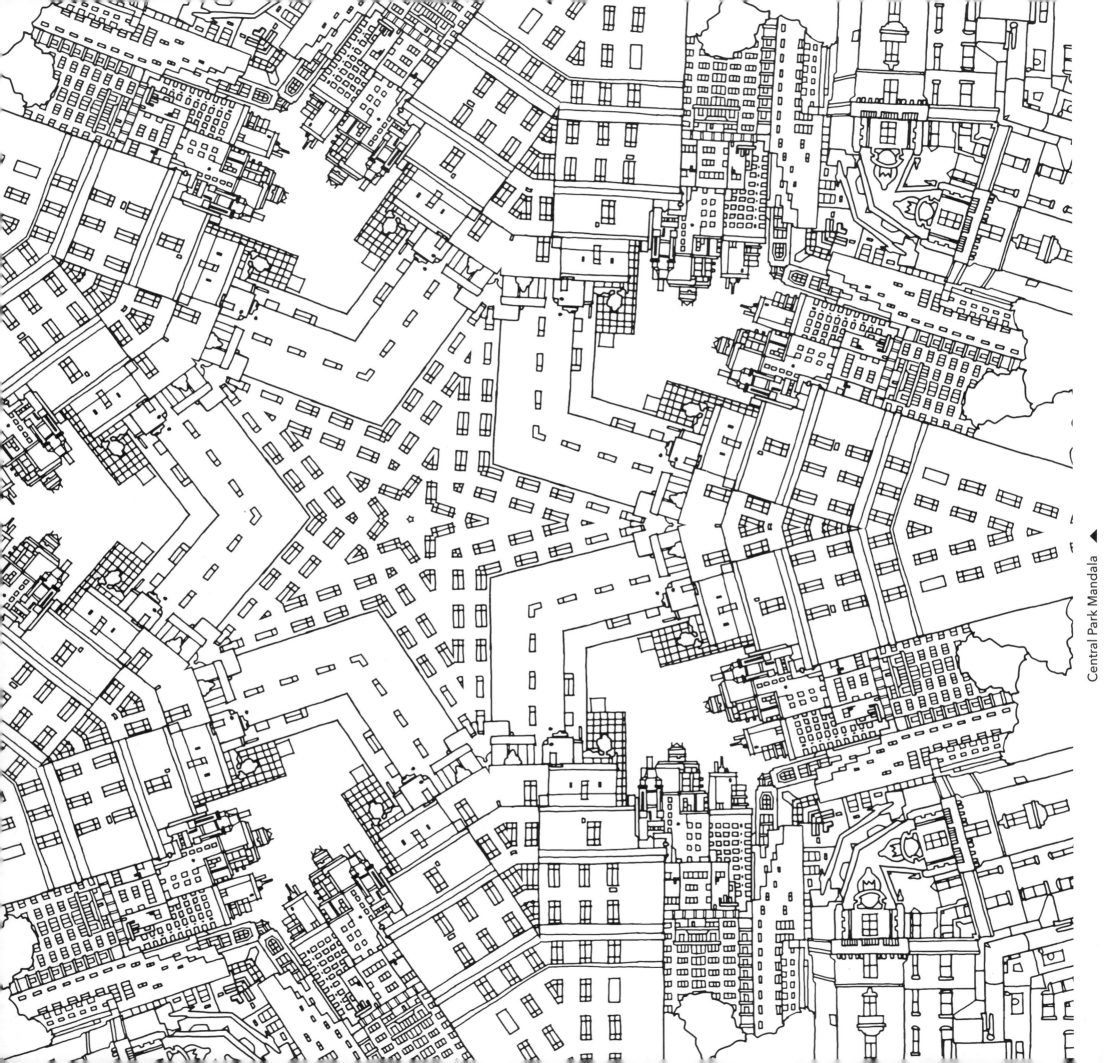

Central Park Mandala

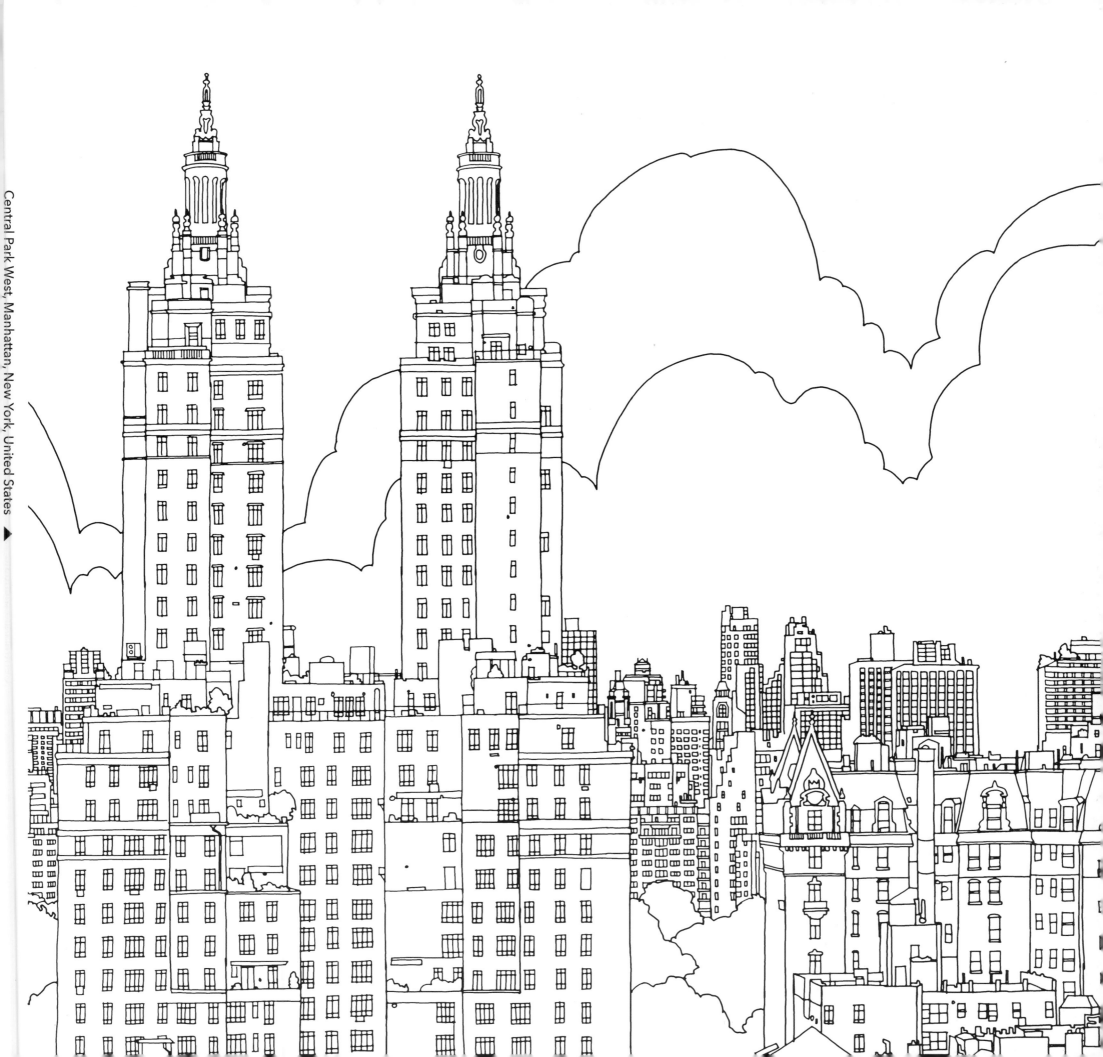

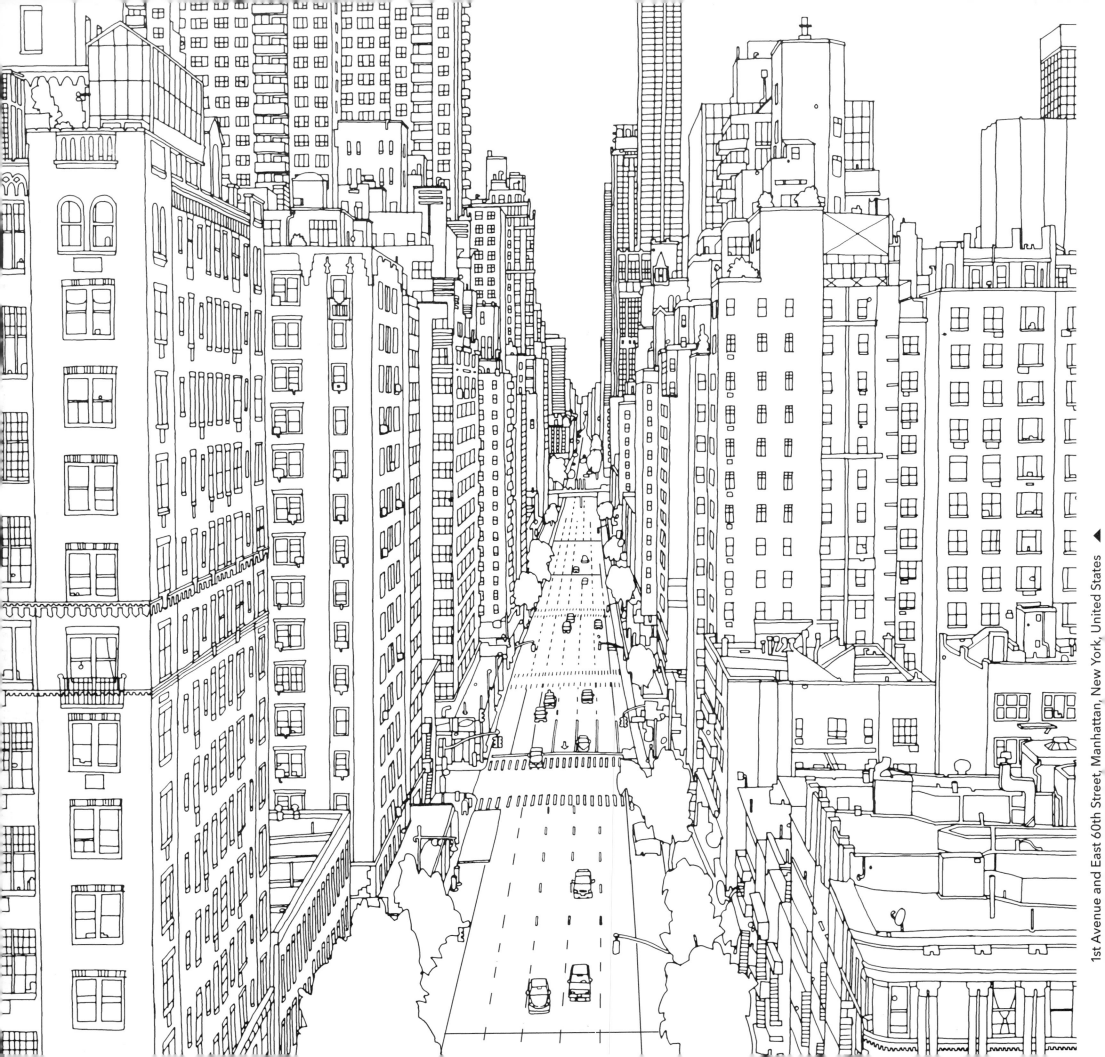

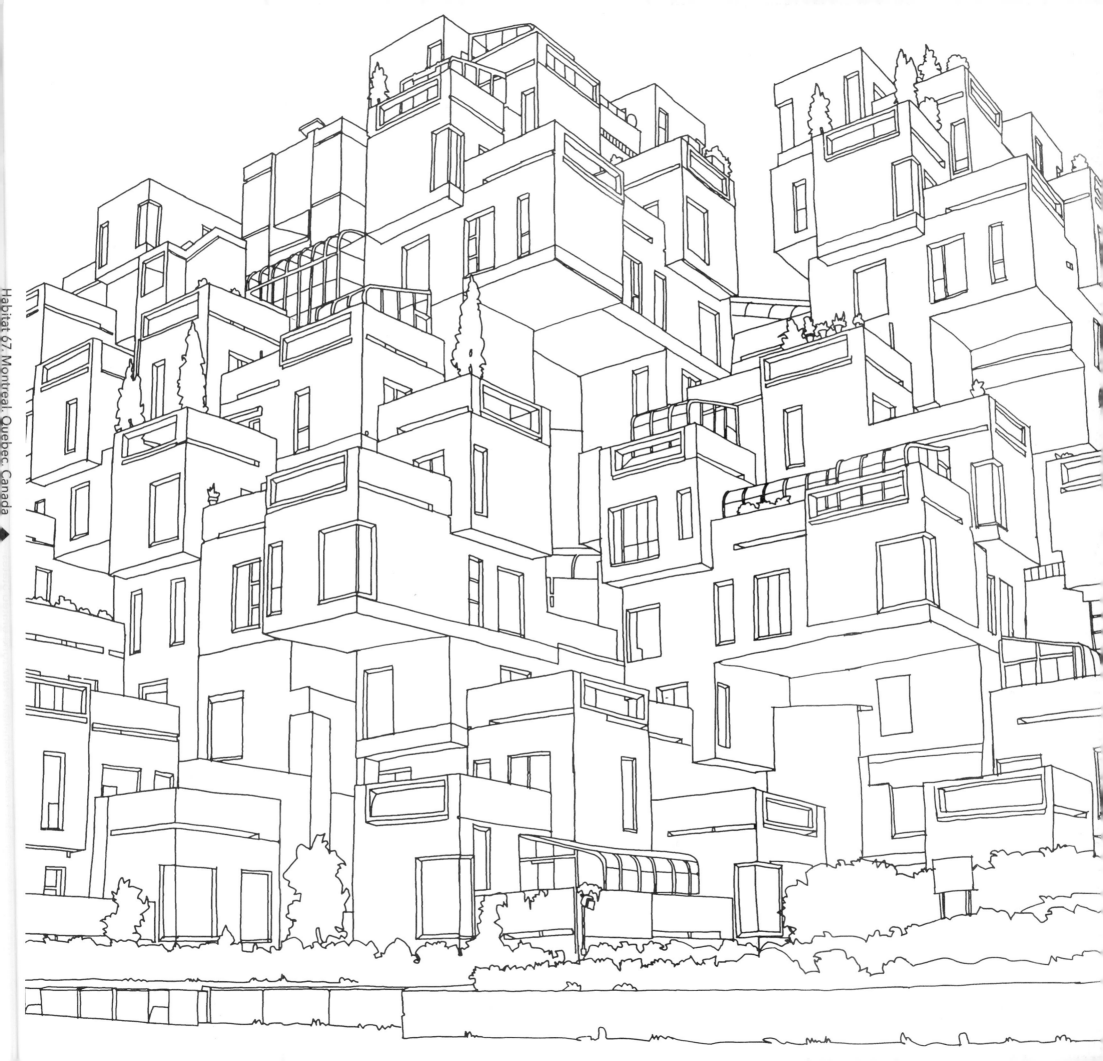

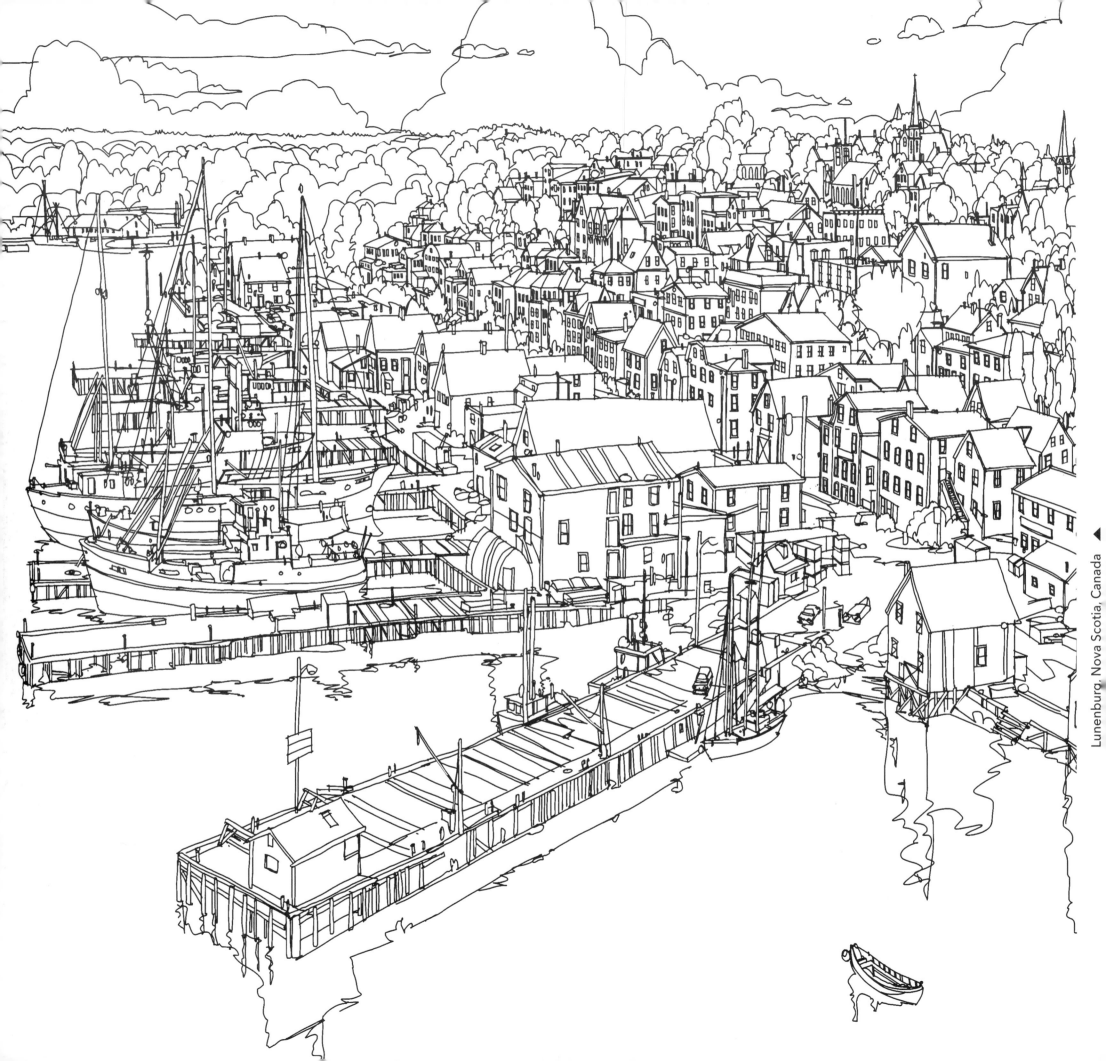

Lunenburg, Nova Scotia, Canada

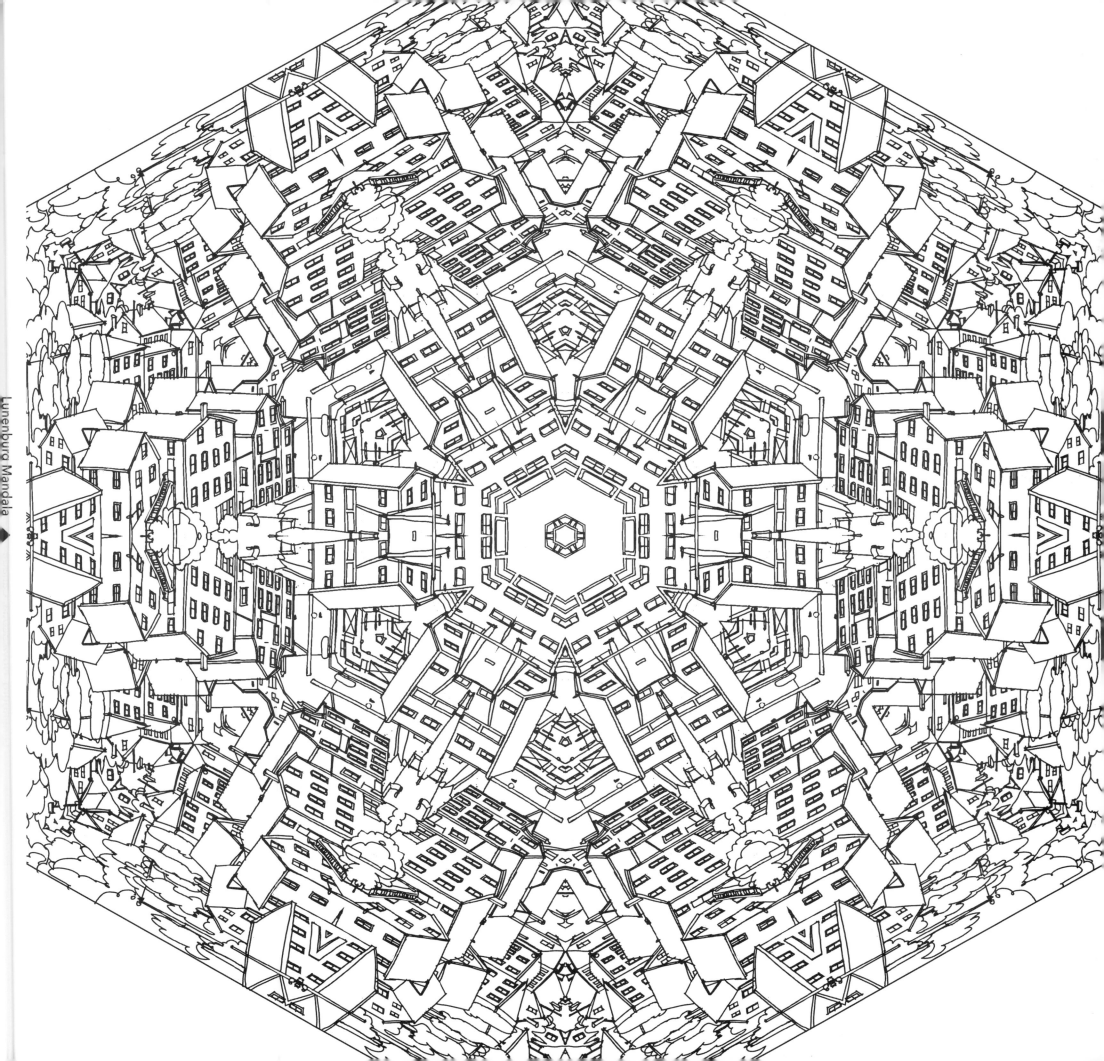

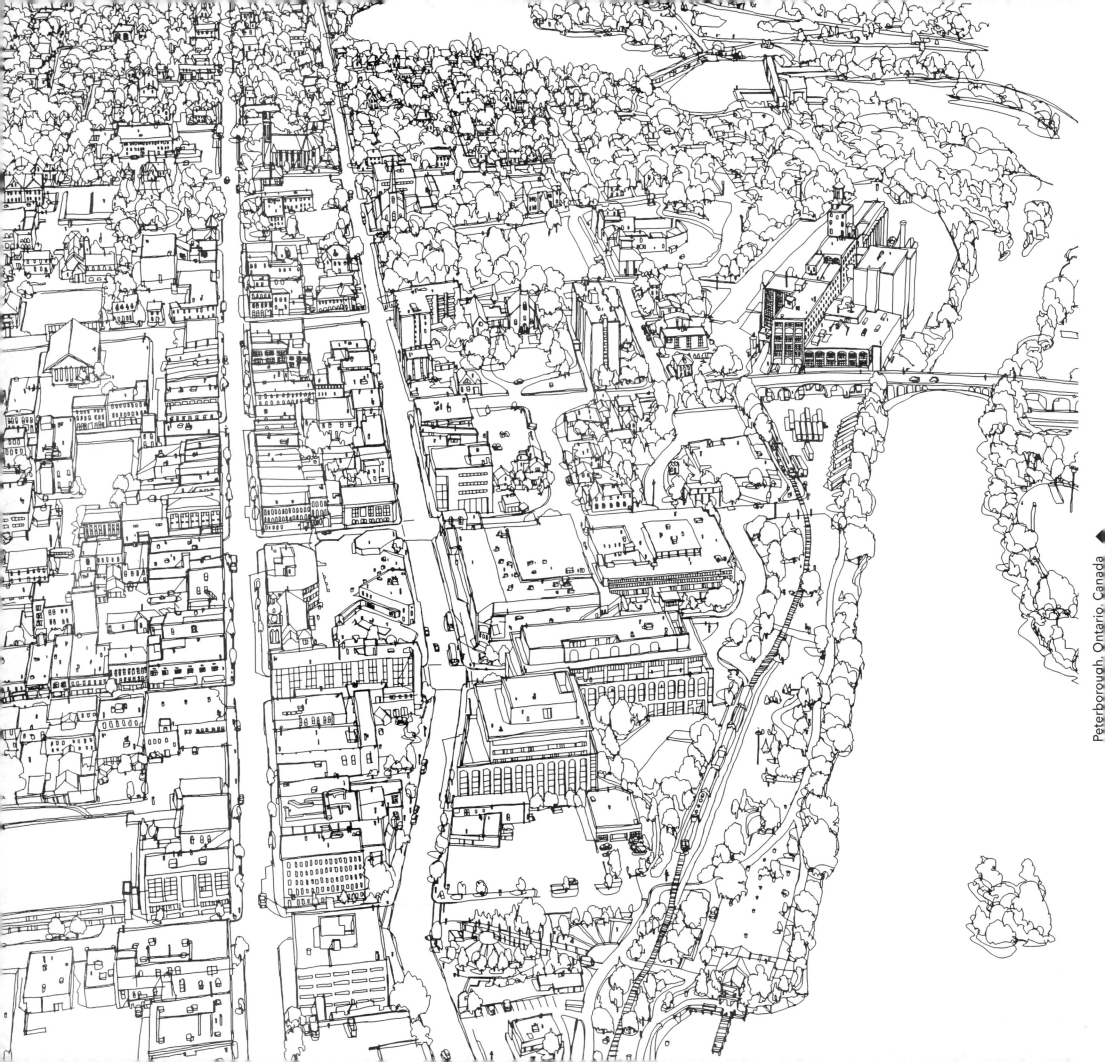

Peterborough, Ontario, Canada

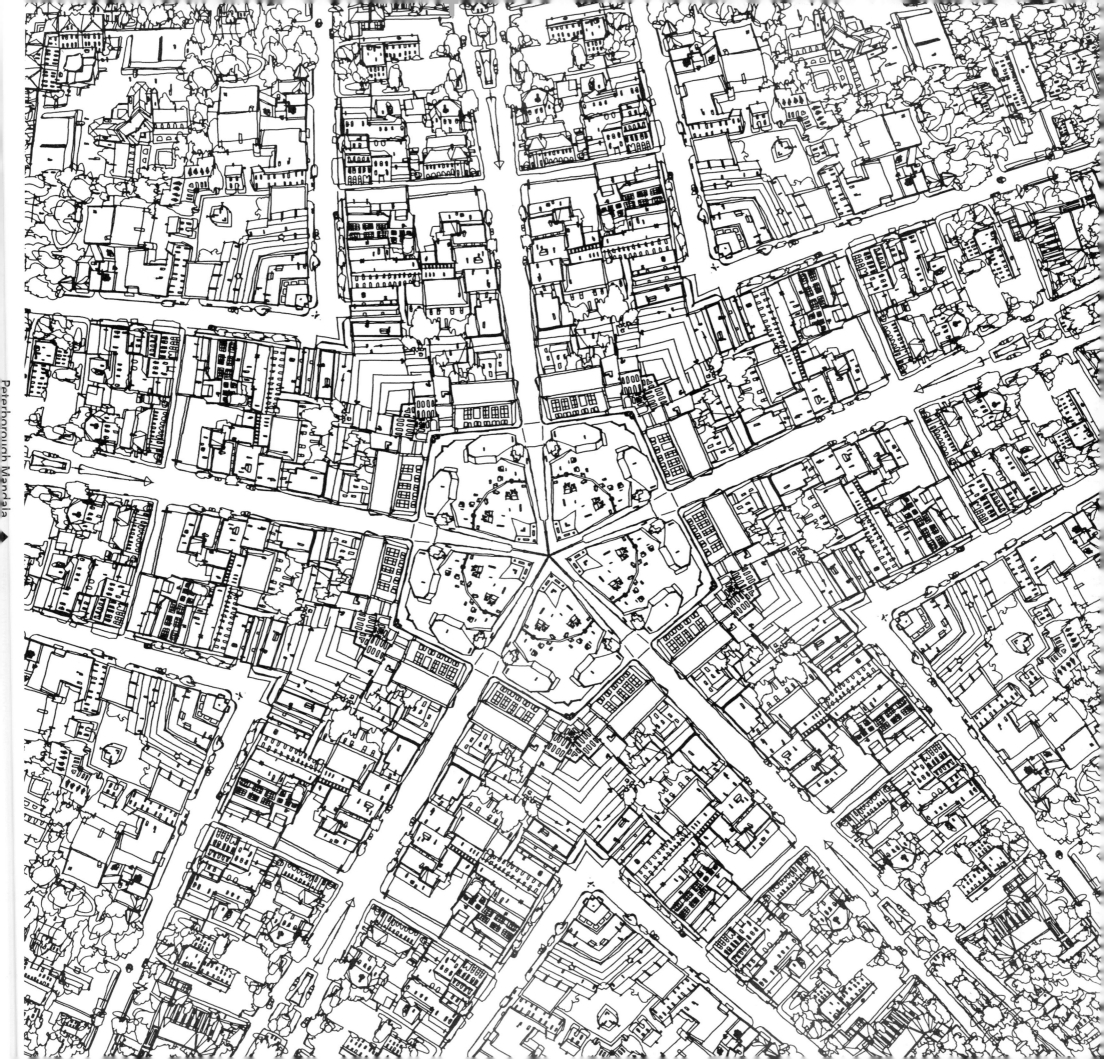

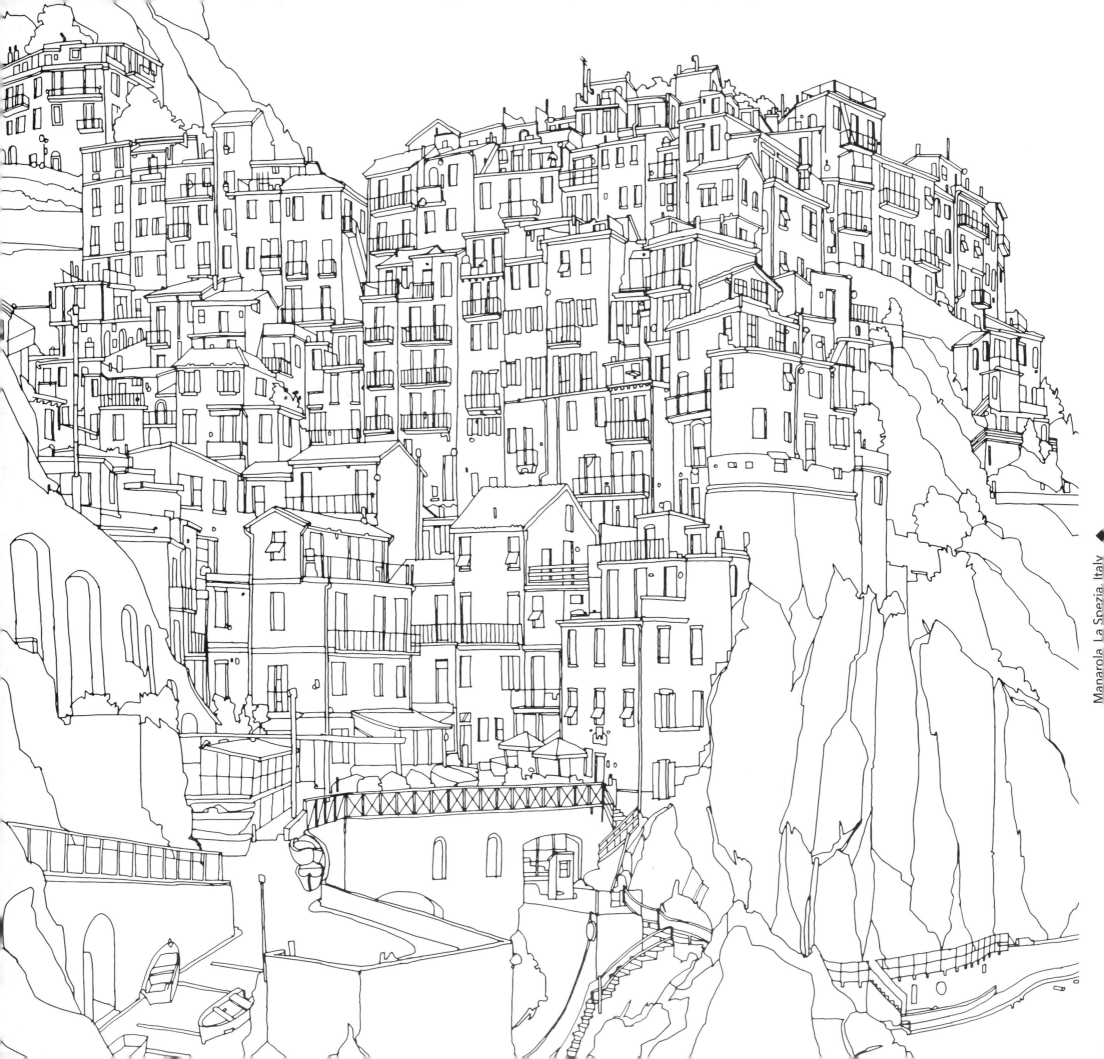

Manarola, La Spezia, Italy

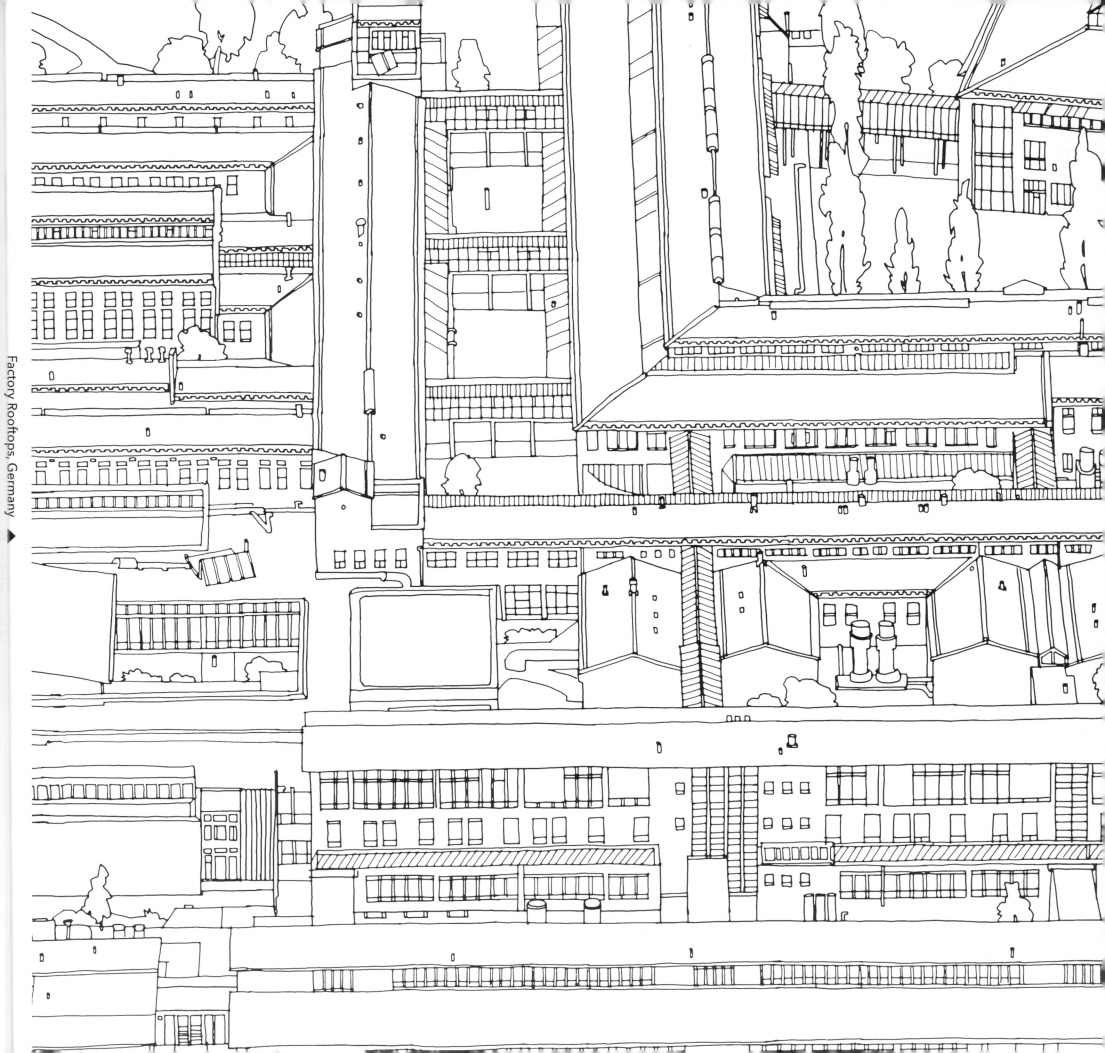

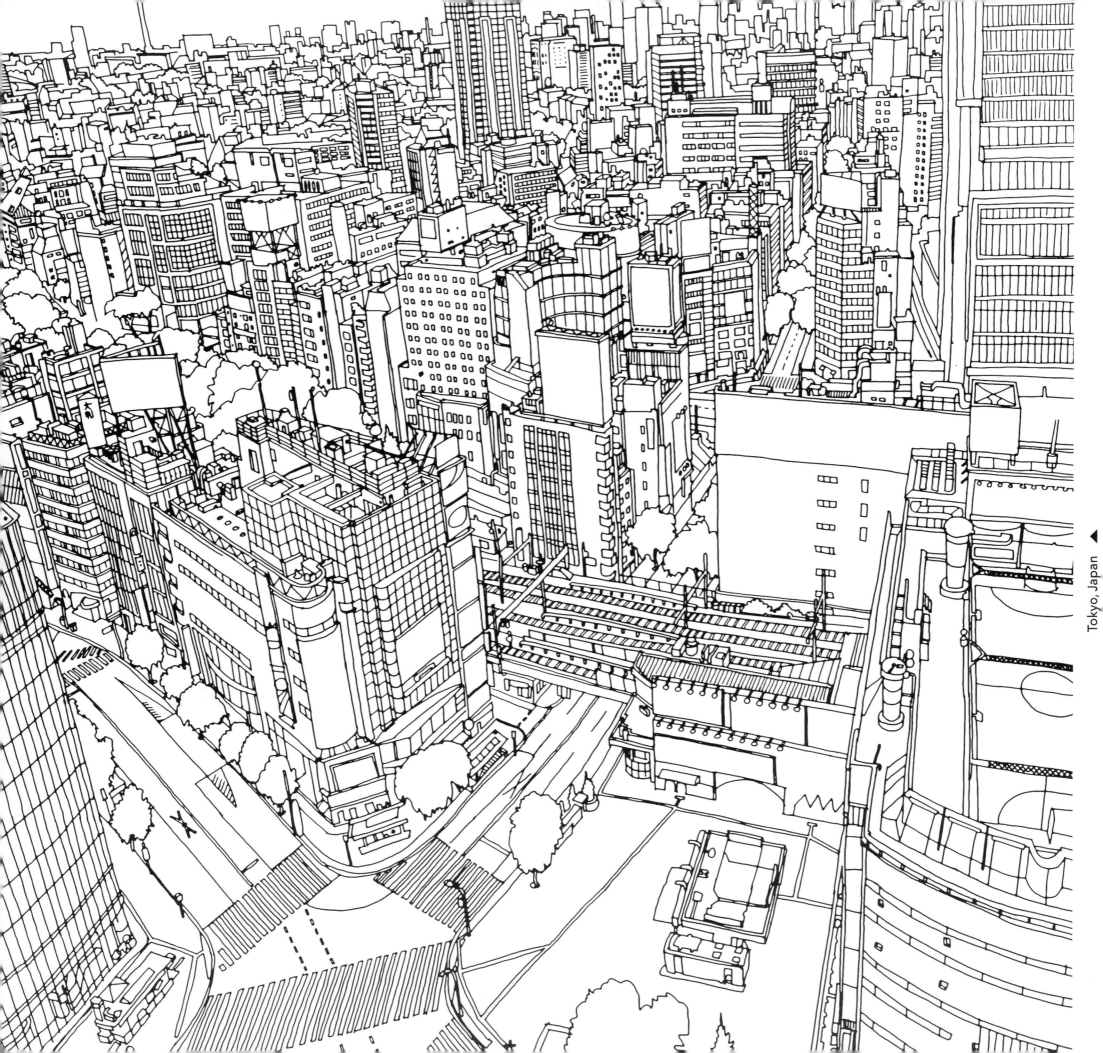

Tokyo, Japan

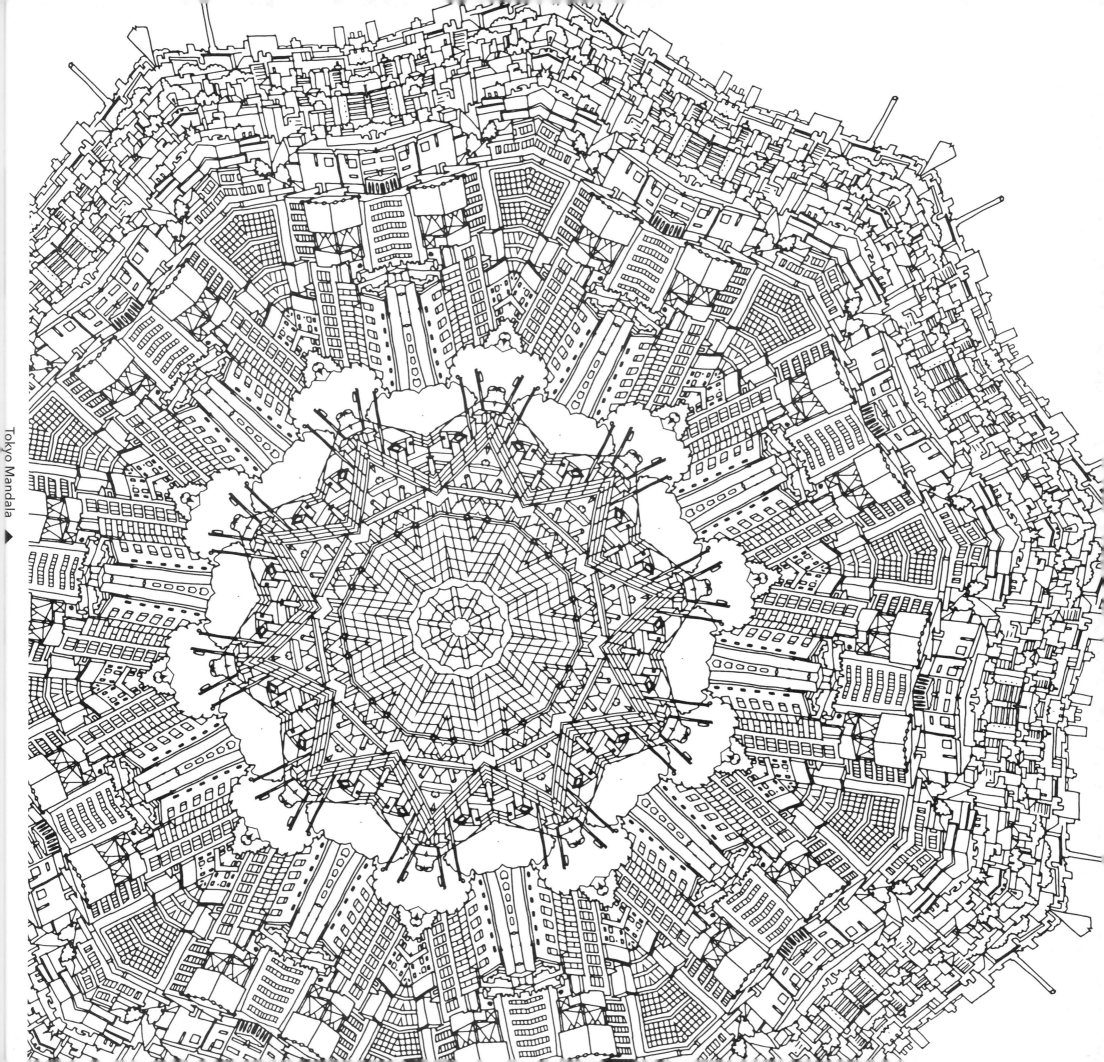

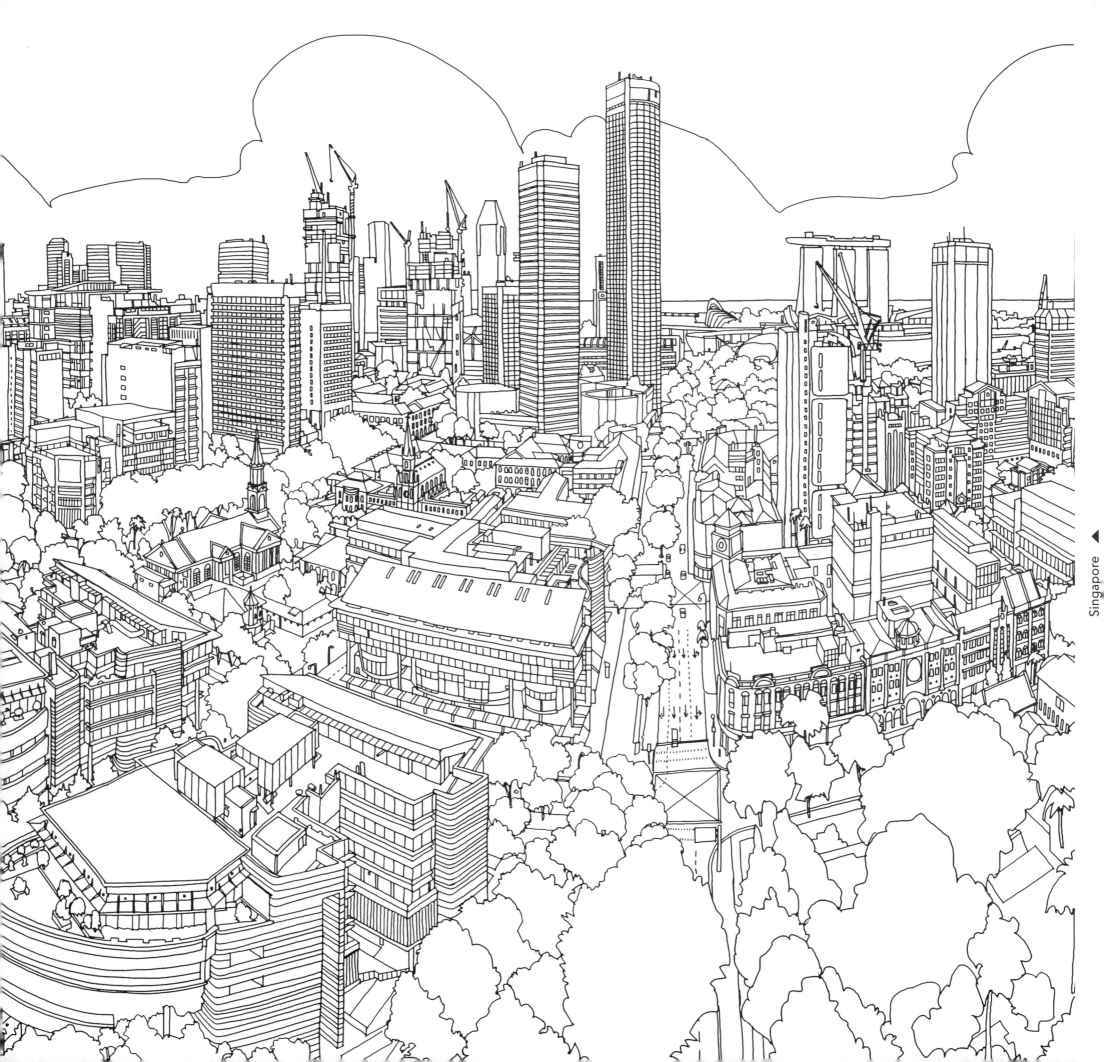

Singapore

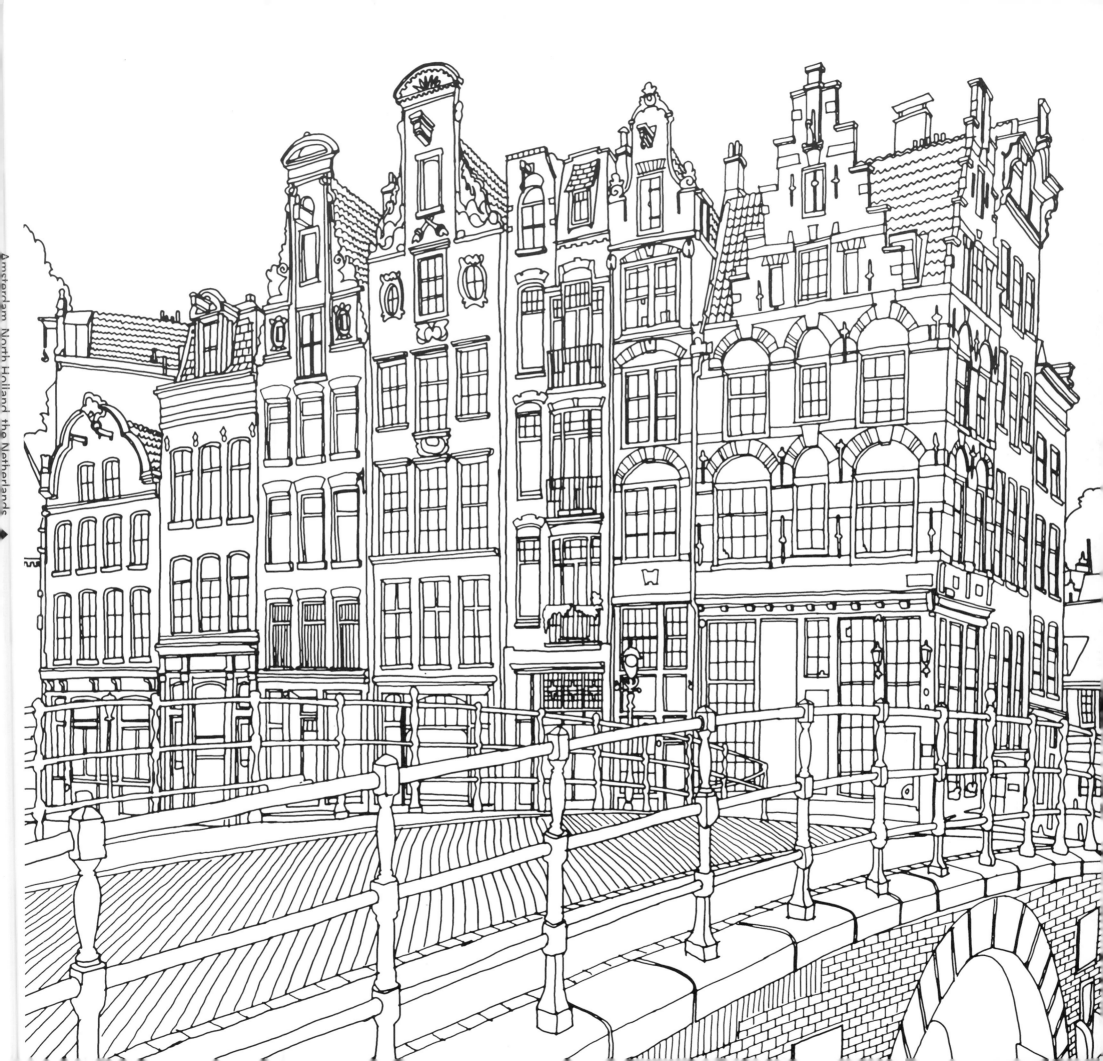

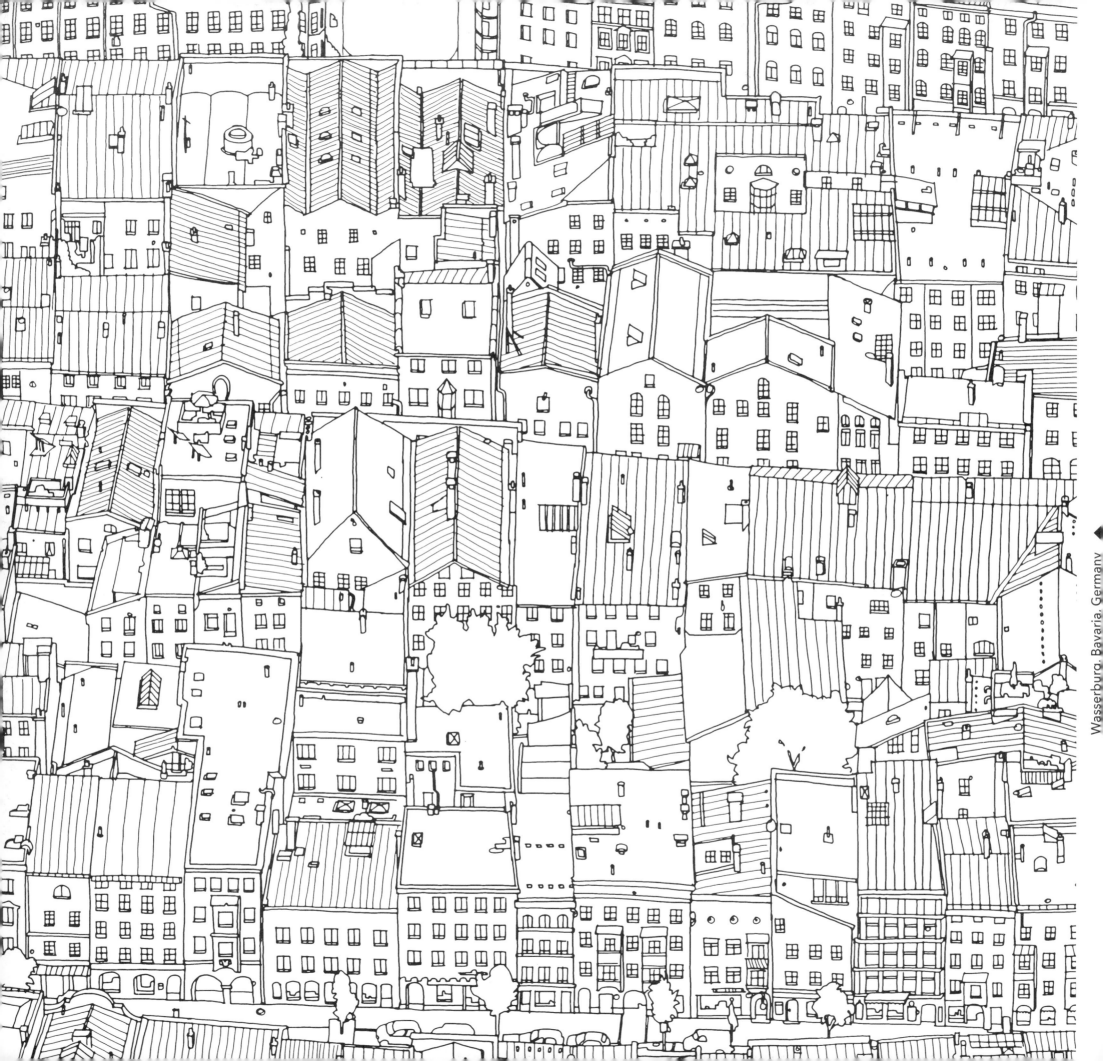

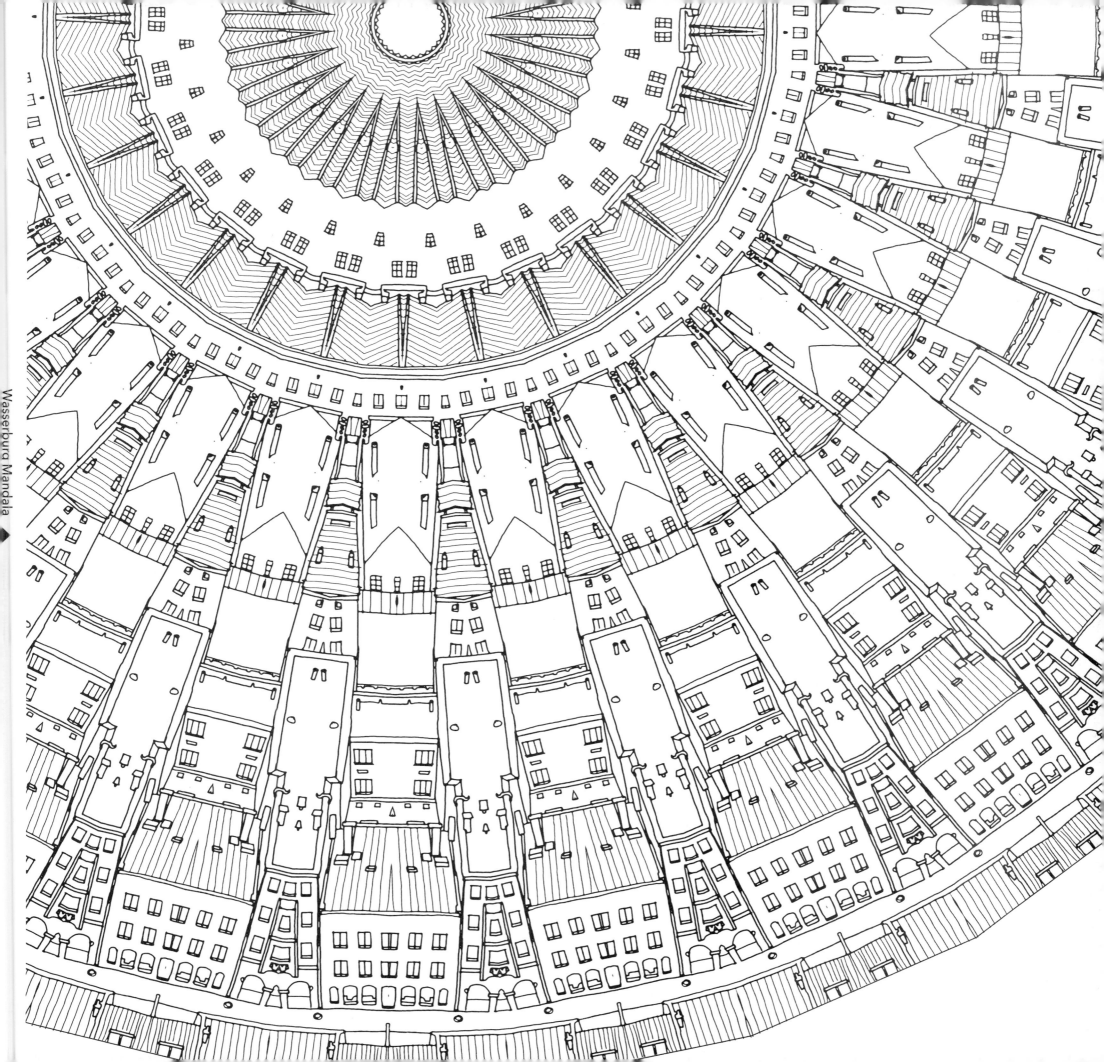

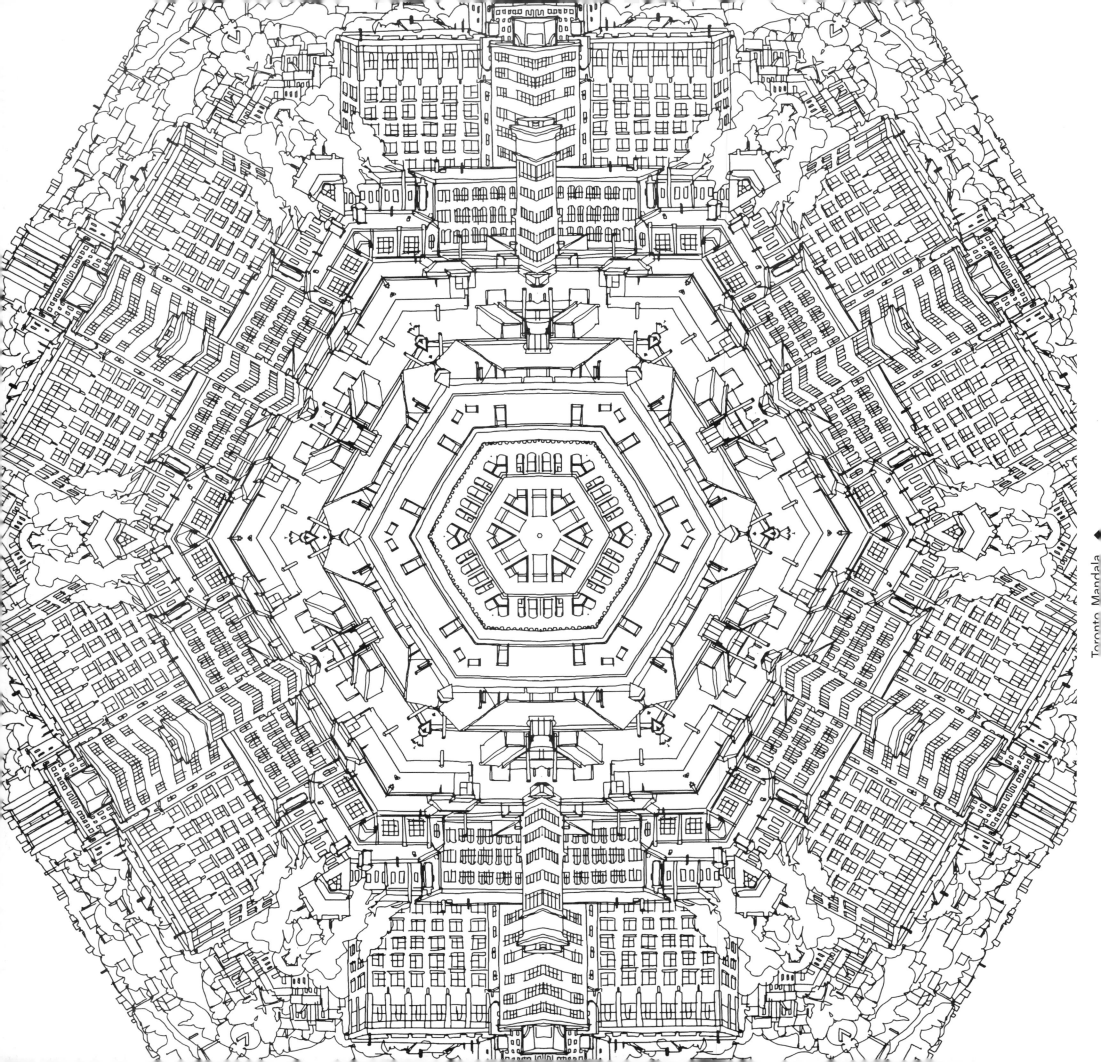

Toronto Mandala

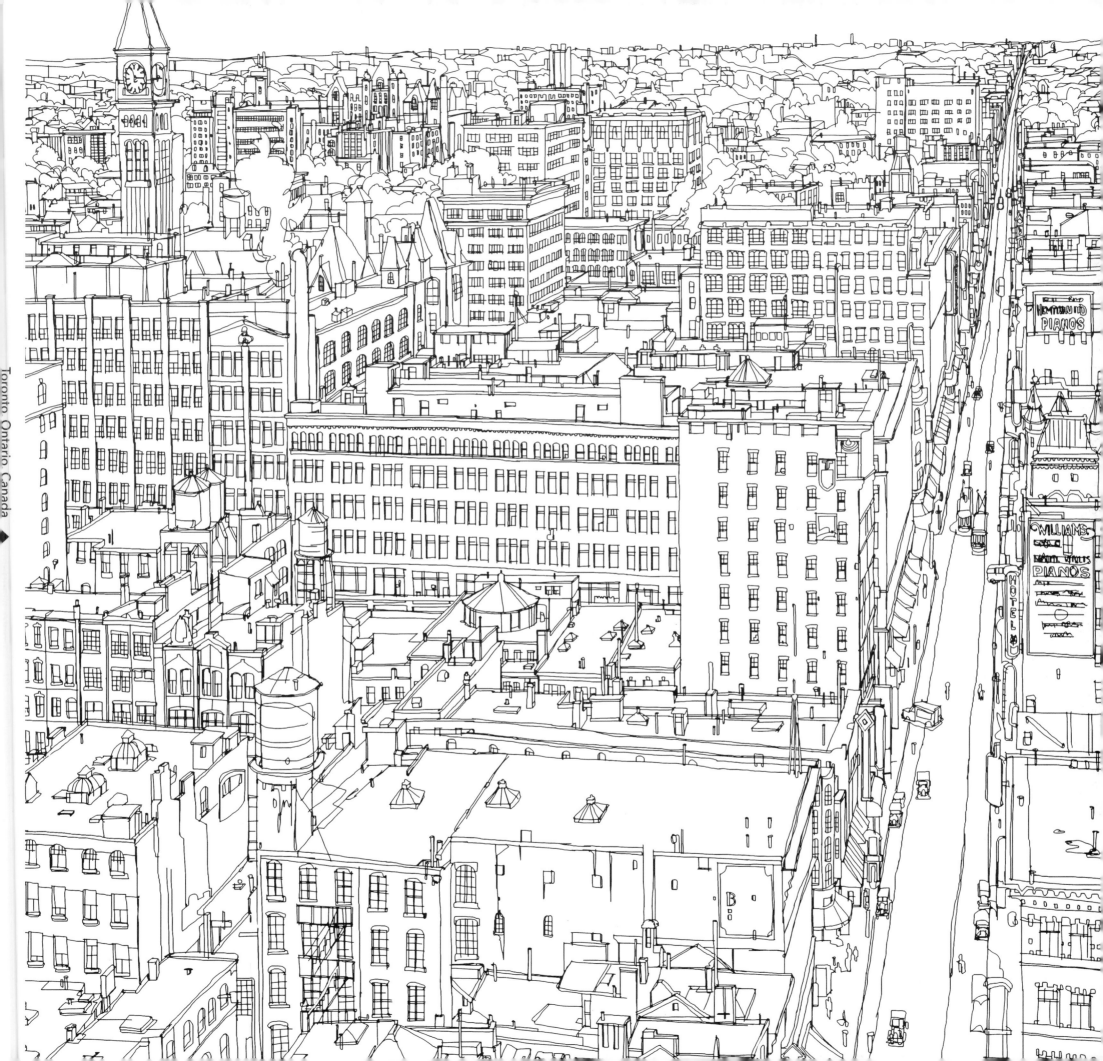

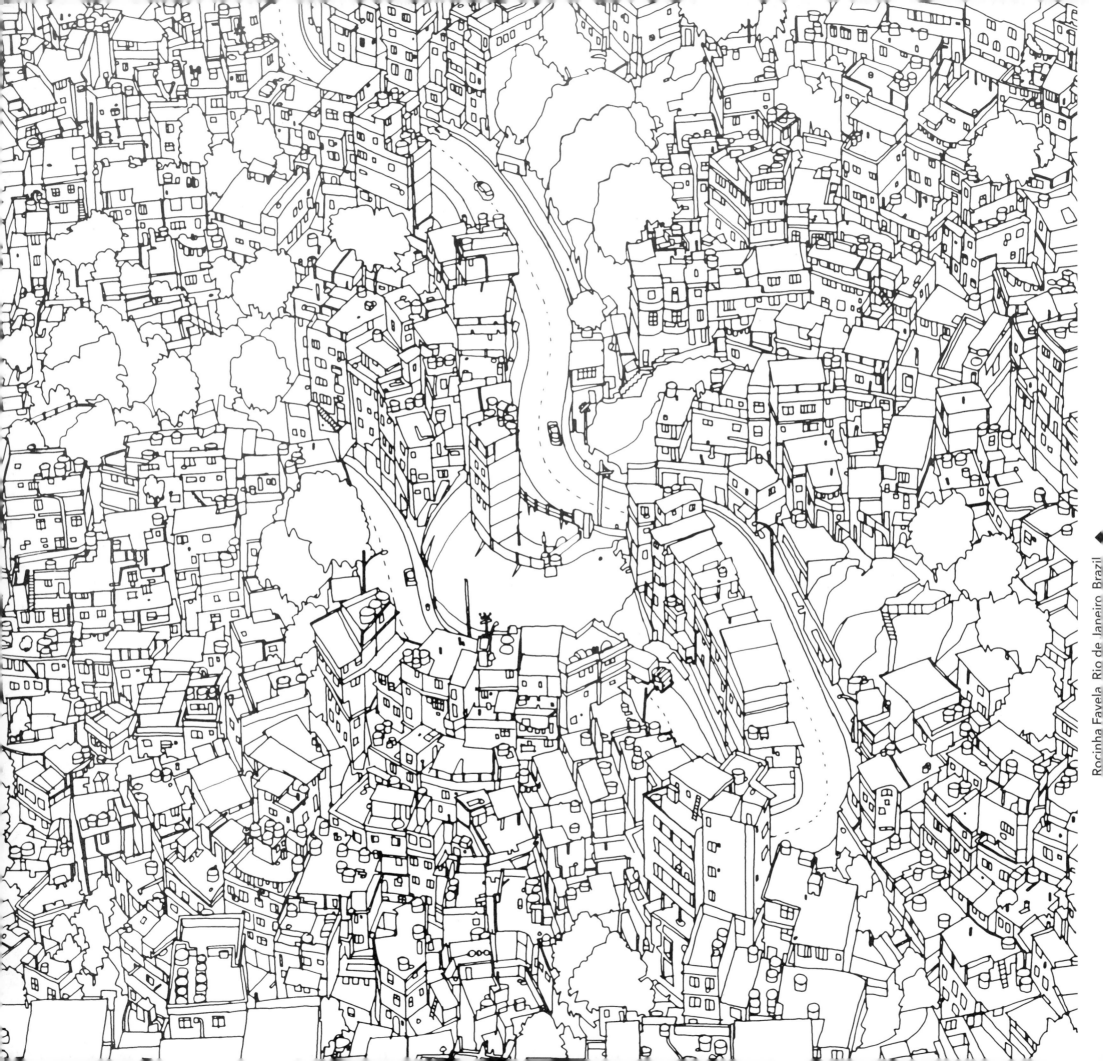

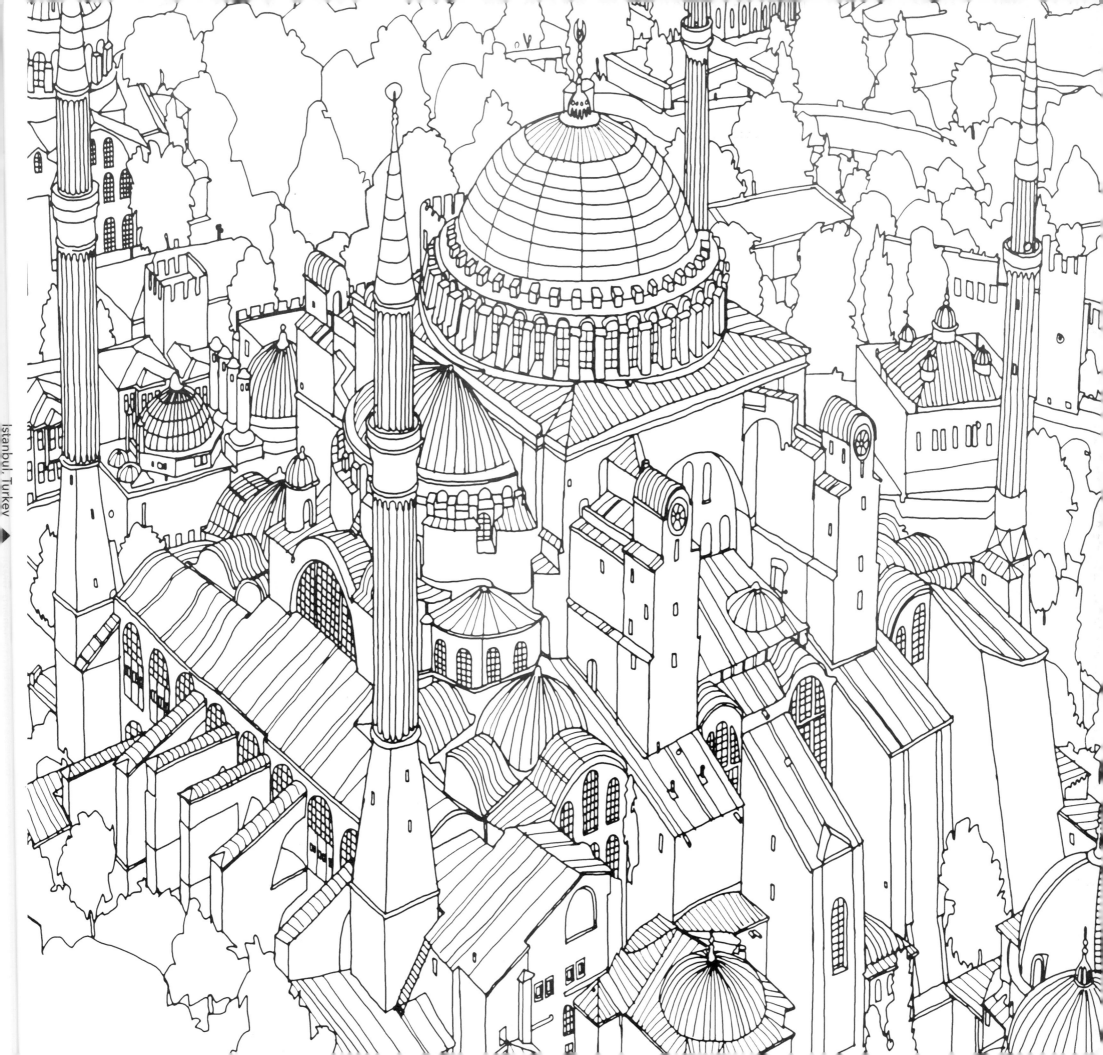

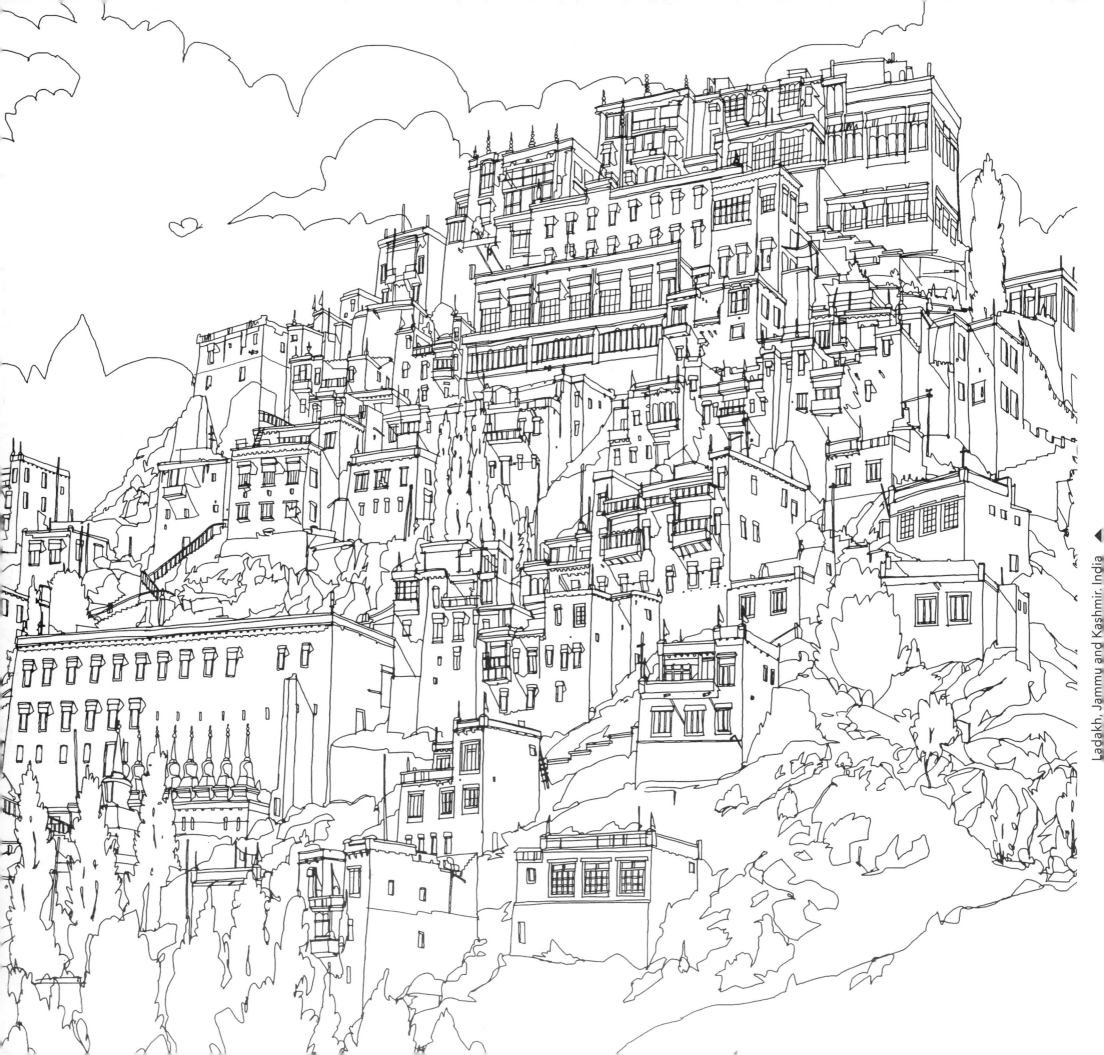

Ladakh, Jammu and Kashmir, India ◢

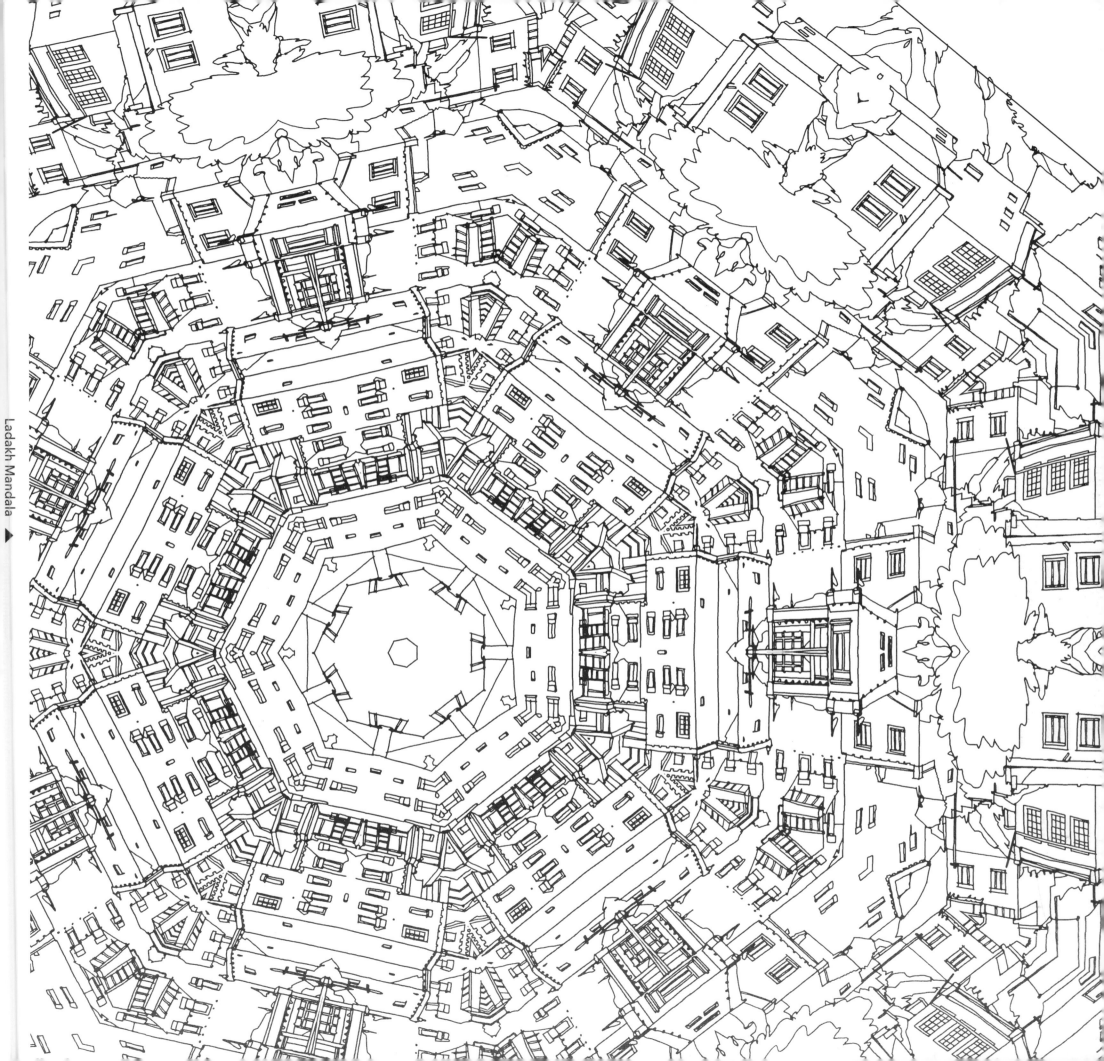

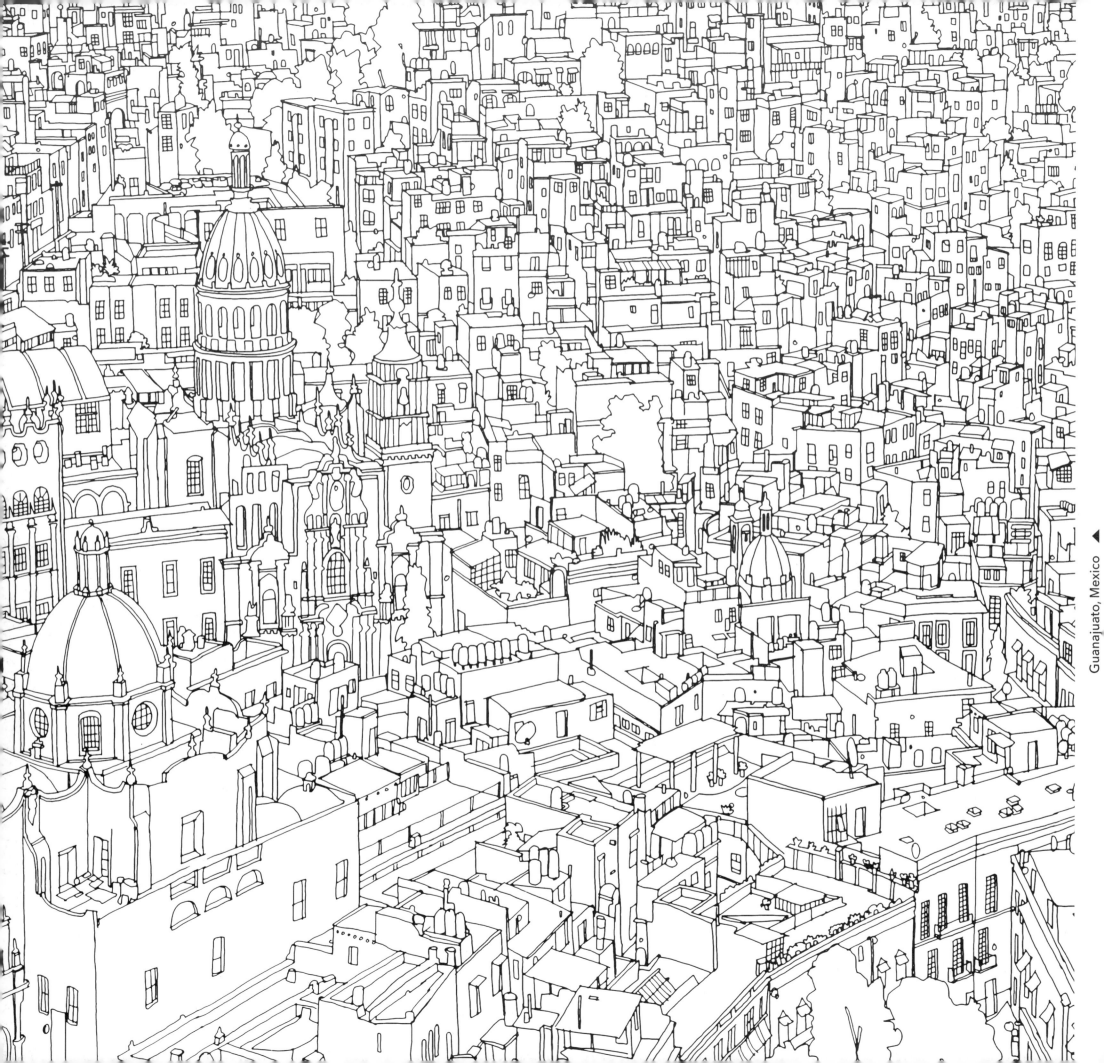

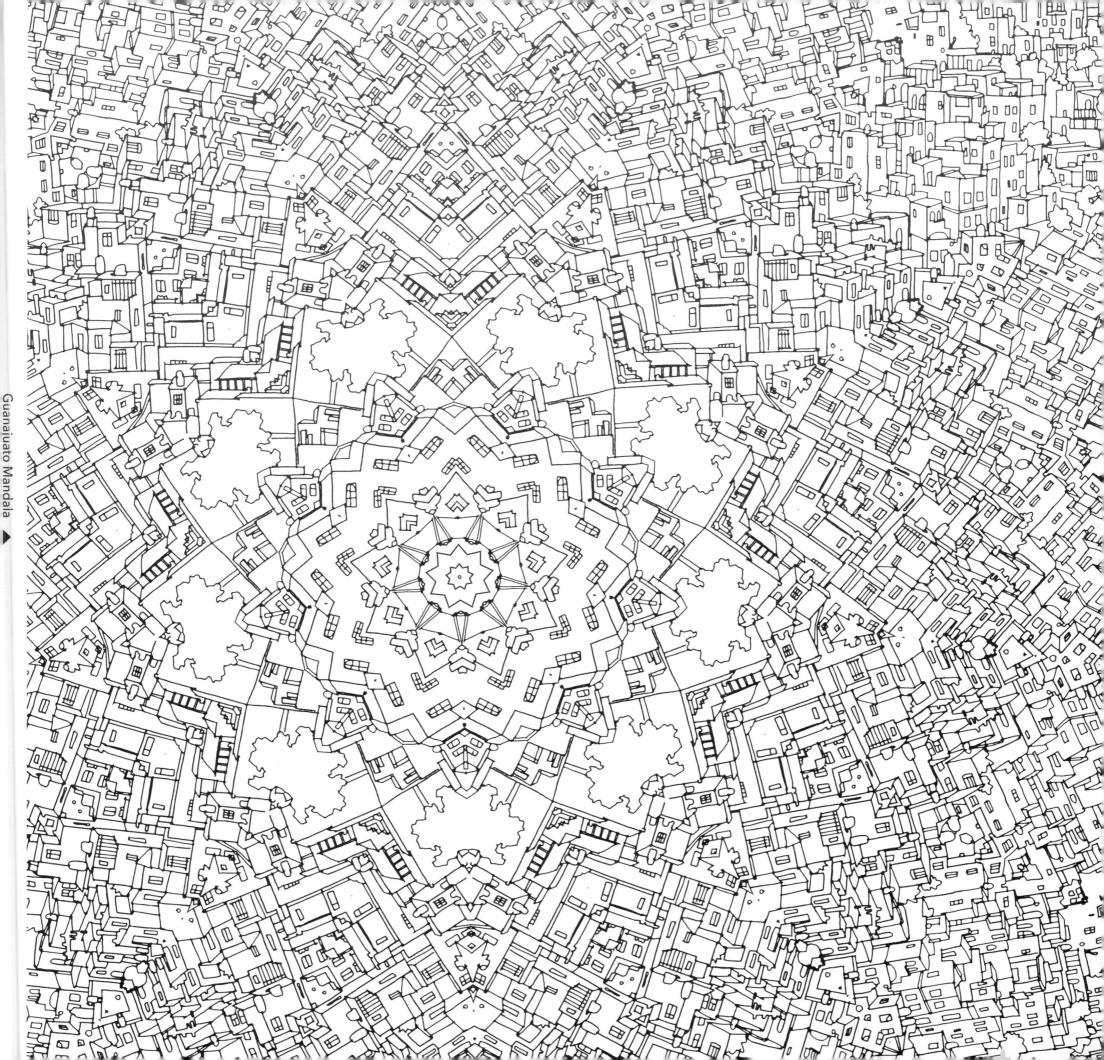

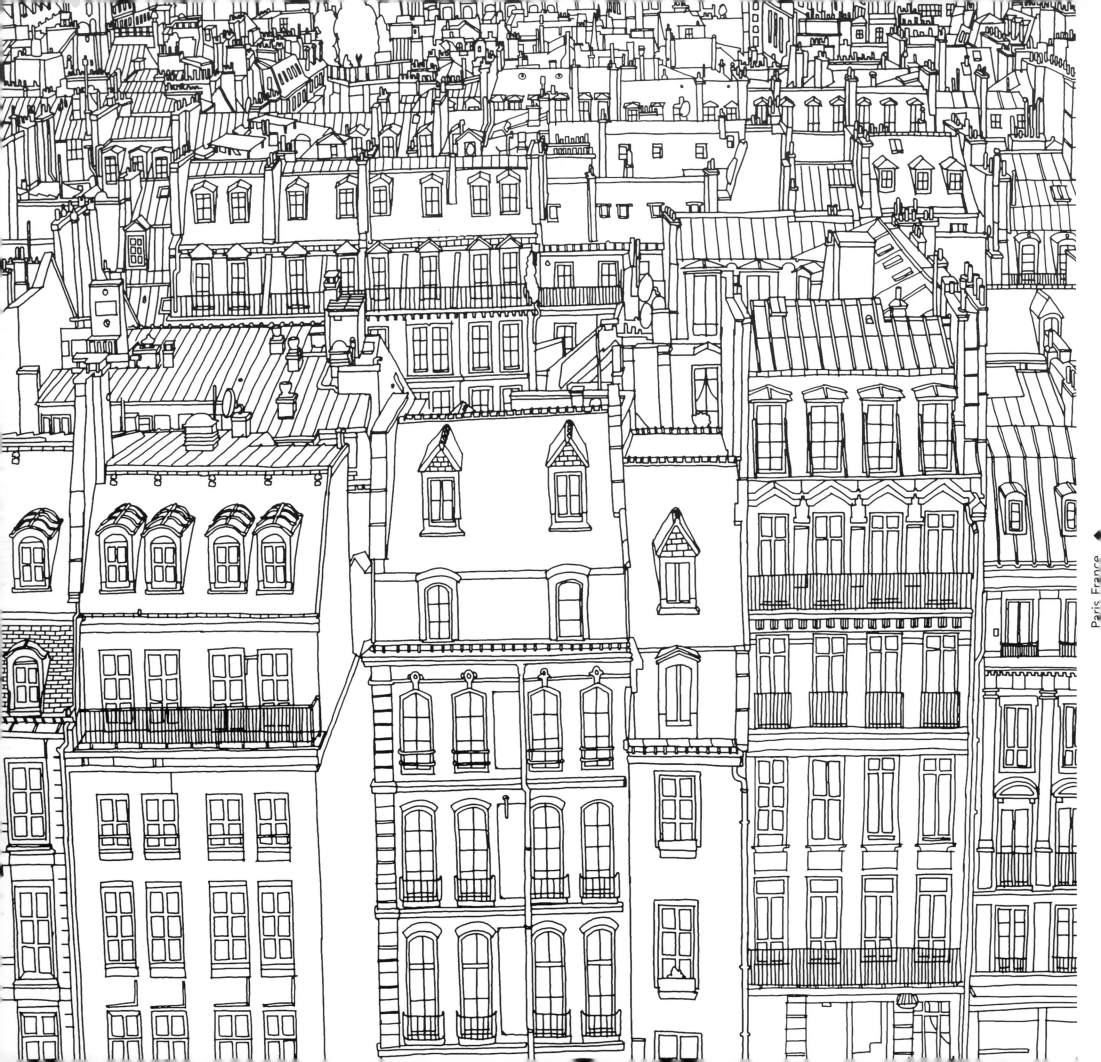

Paris France

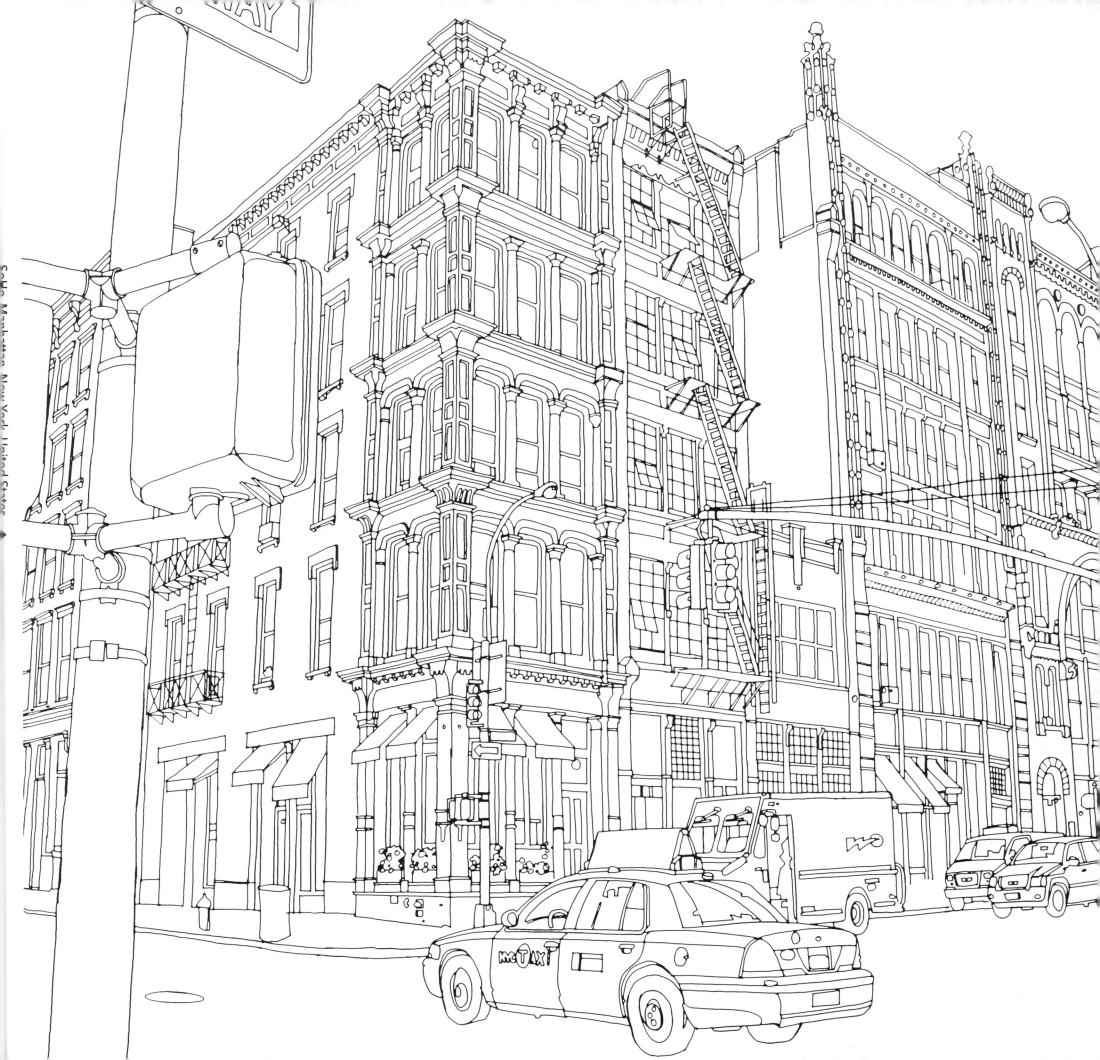

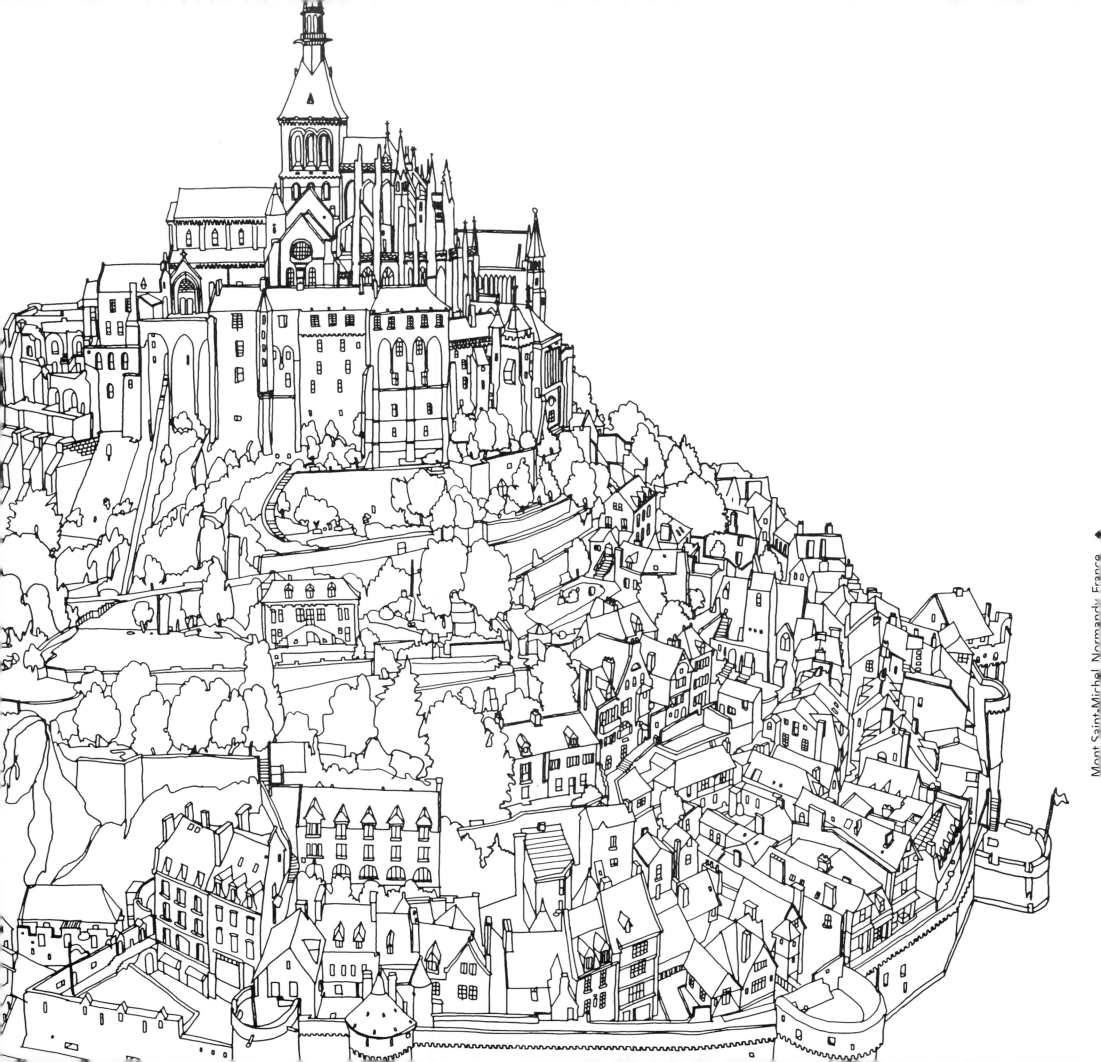

Mont Saint-Michel Normandy France

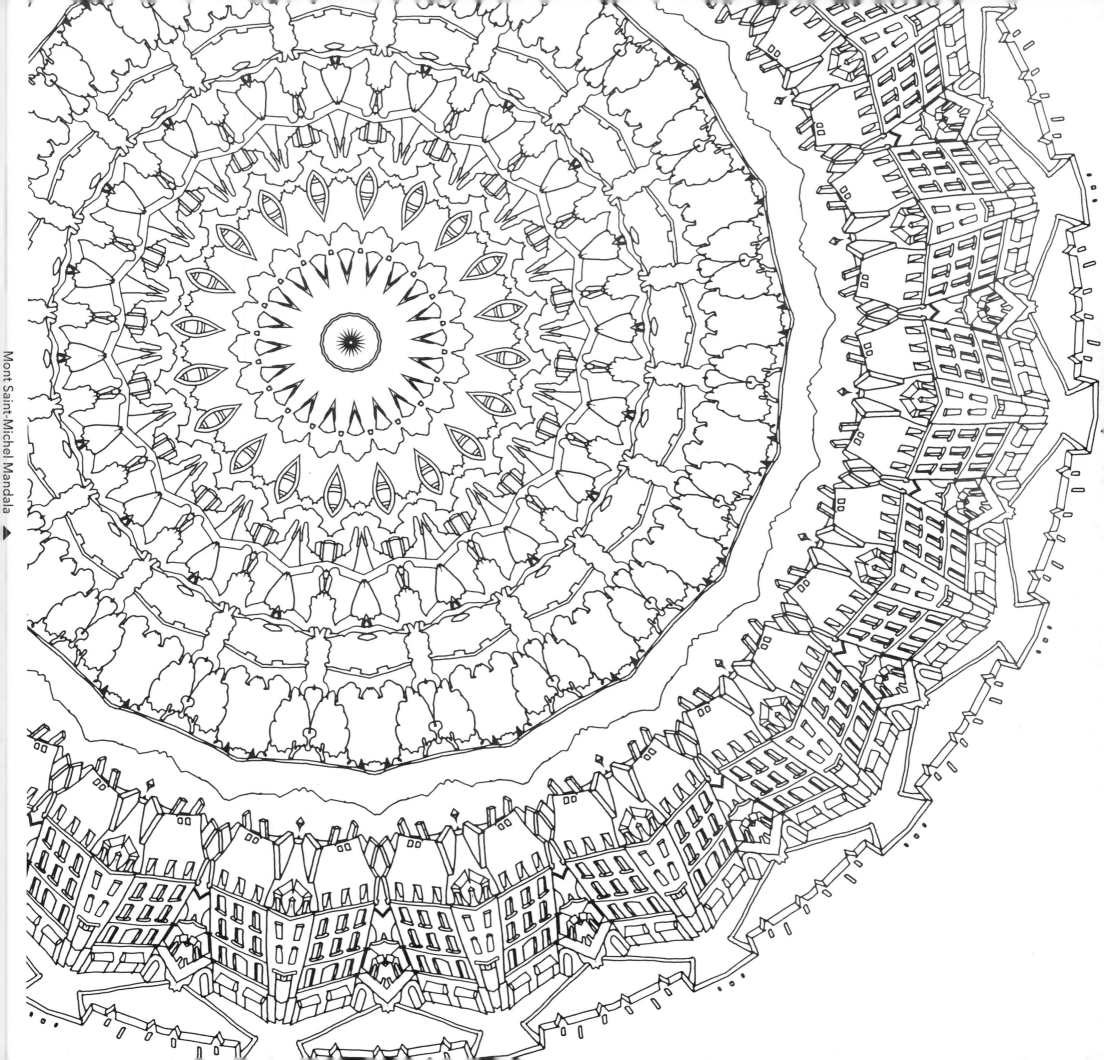

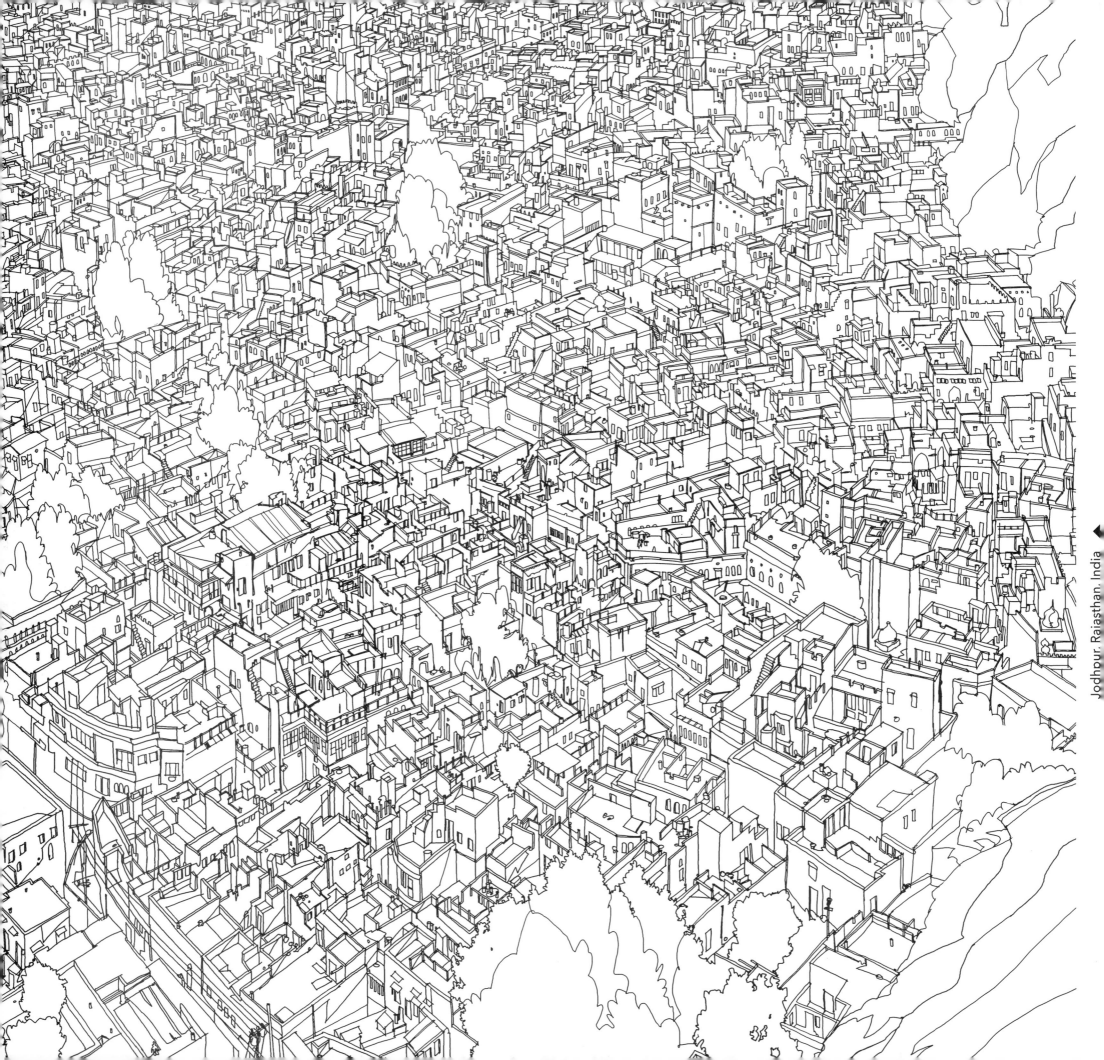

Jodhpur, Rajasthan, India

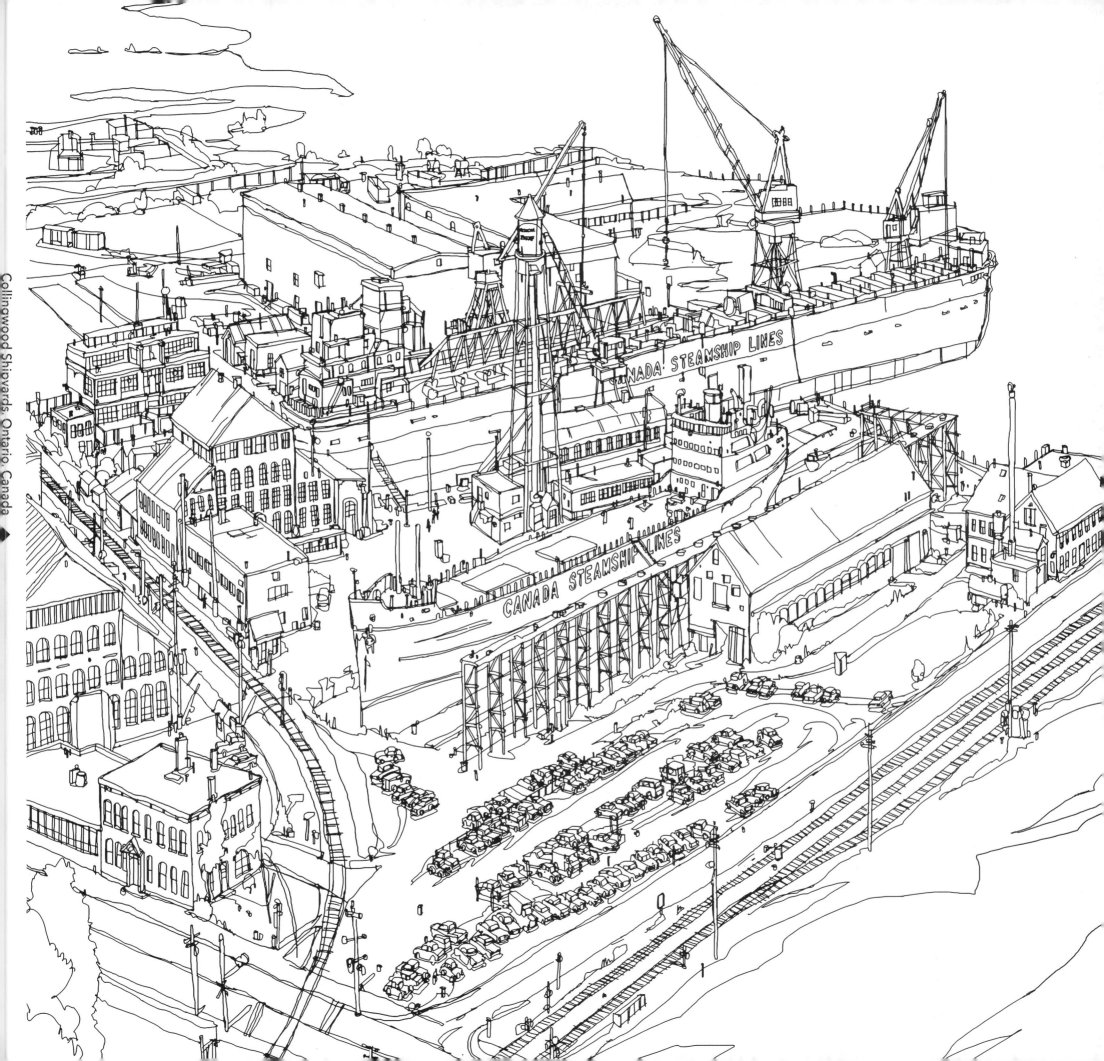

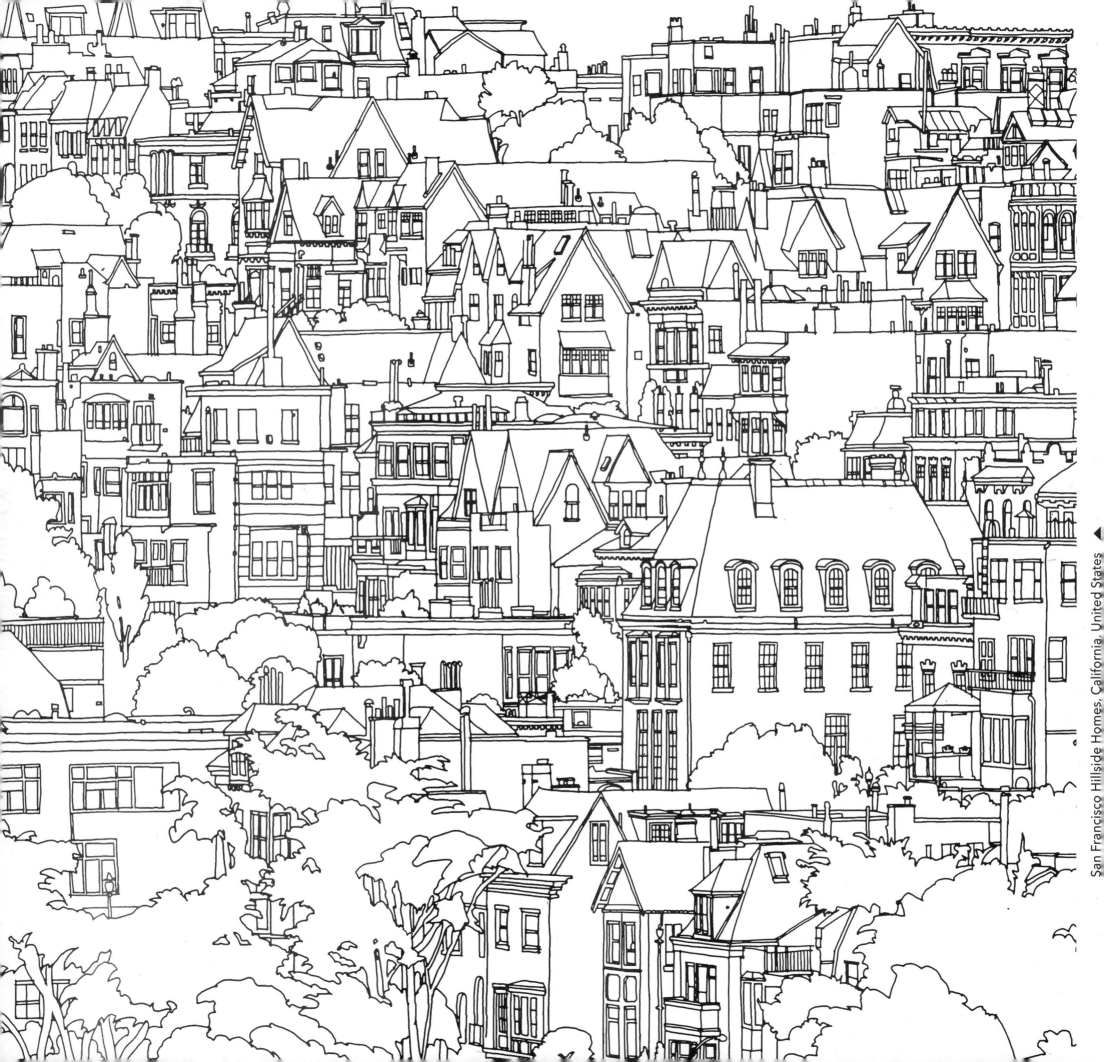

San Francisco Hillside Homes, California, United States ▲

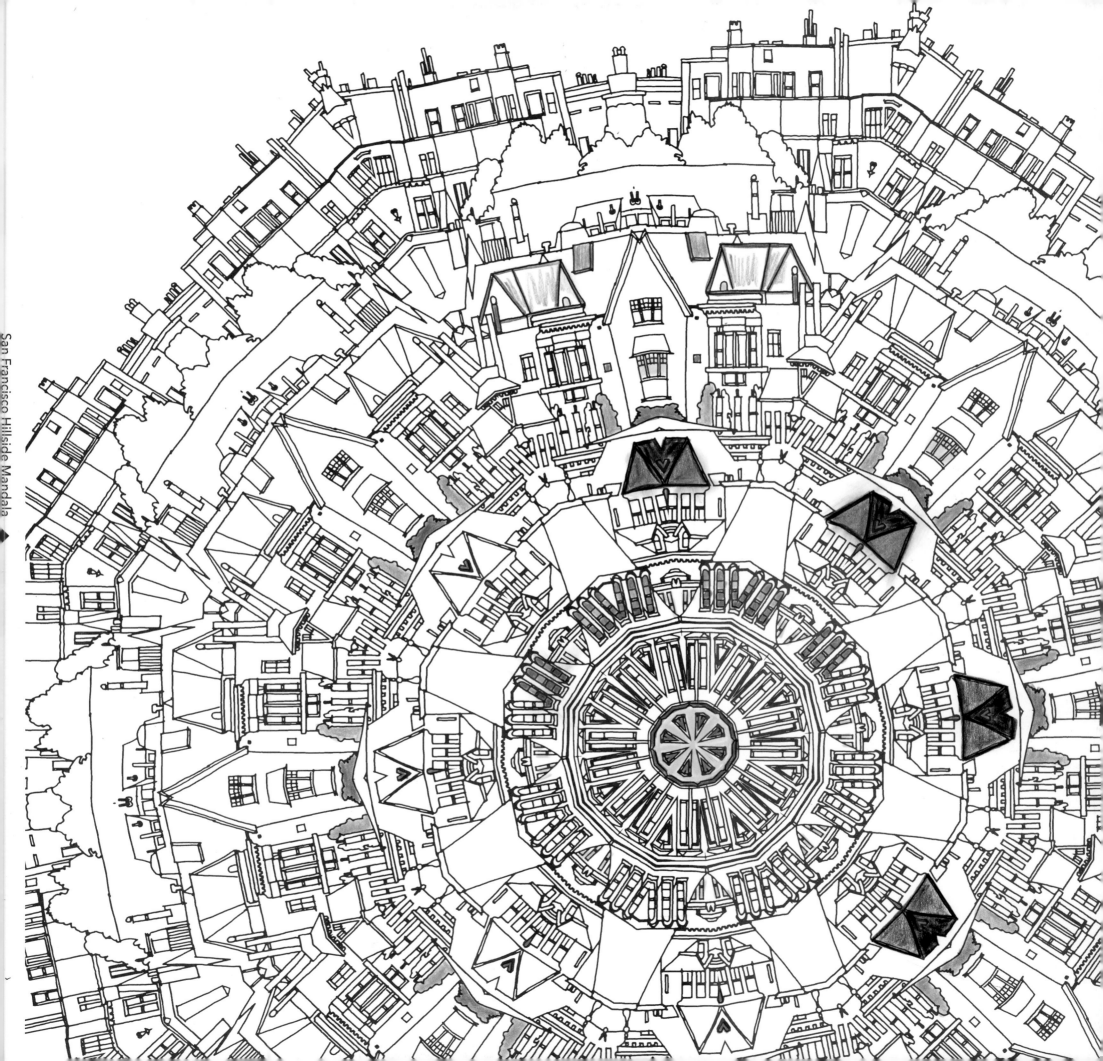

San Francisco Hillside Mandala

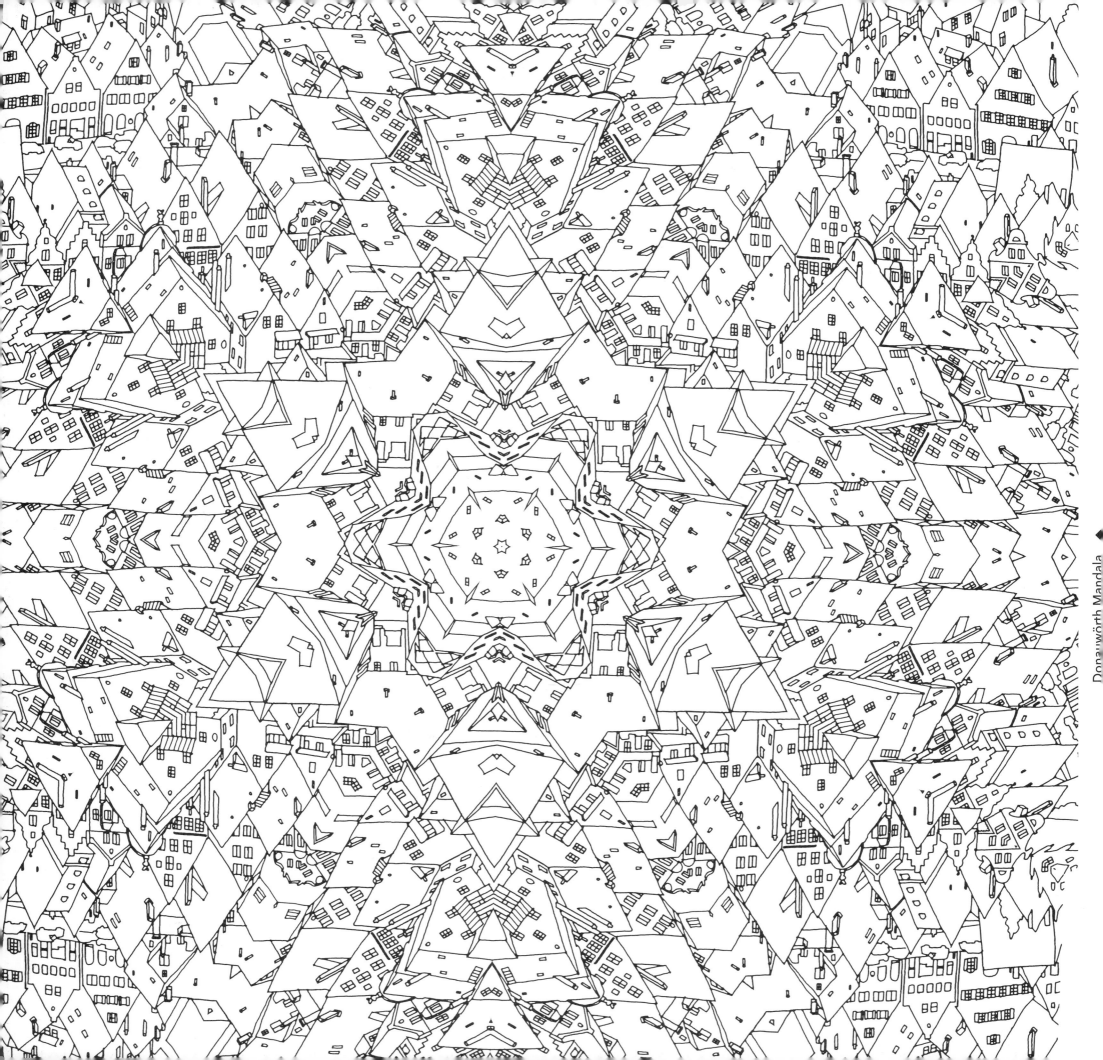

Donauwörth Mandala

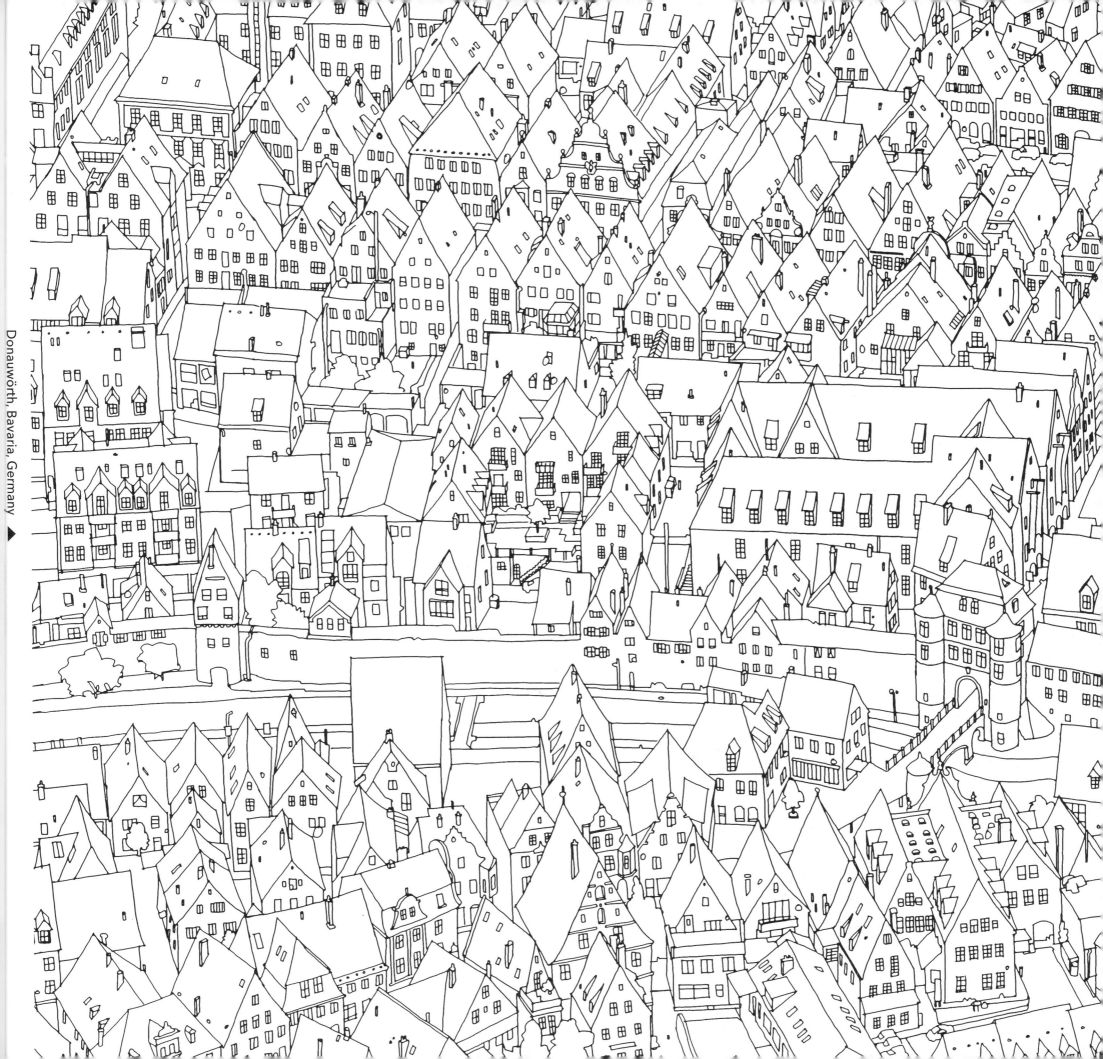

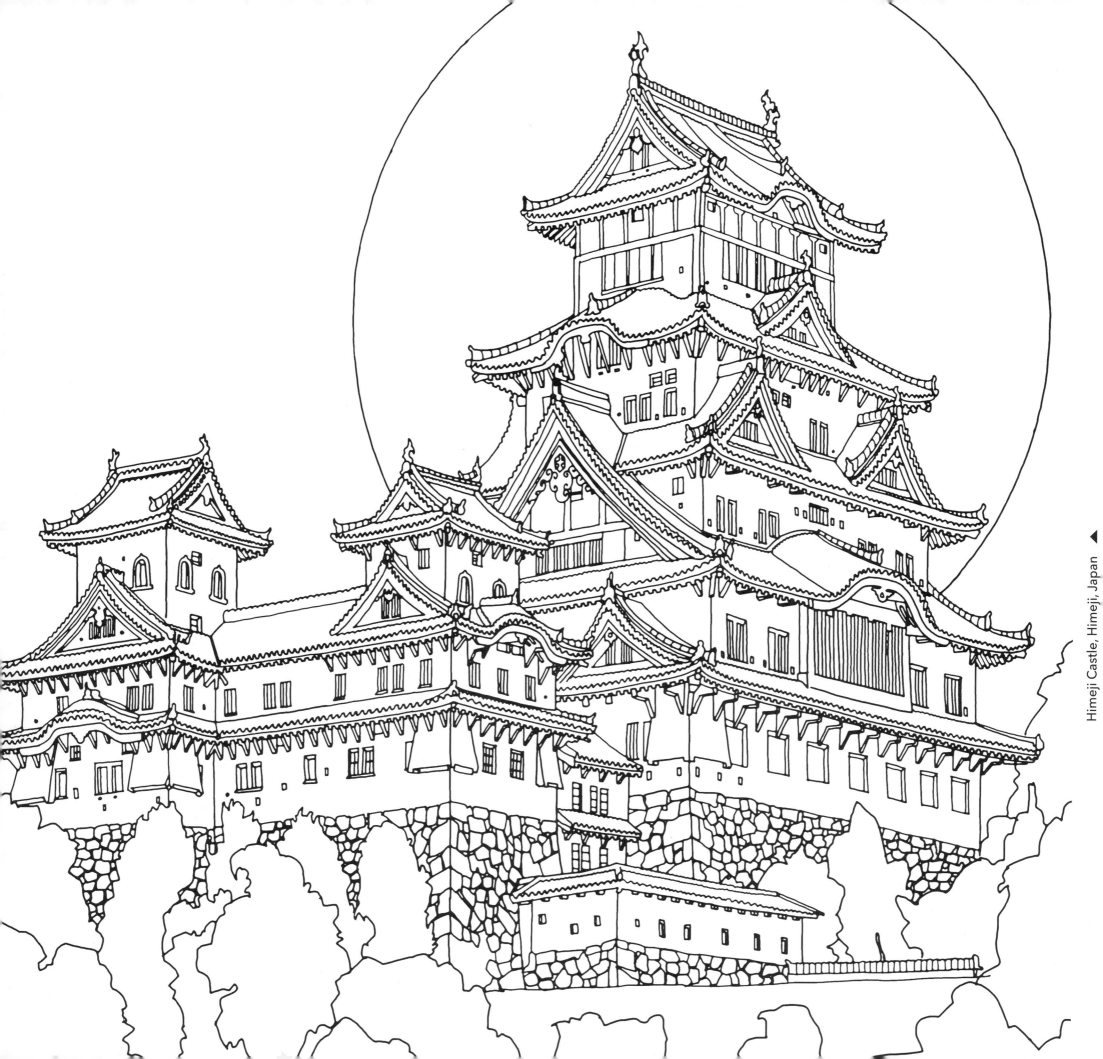

Himeji Castle, Himeji, Japan ◄

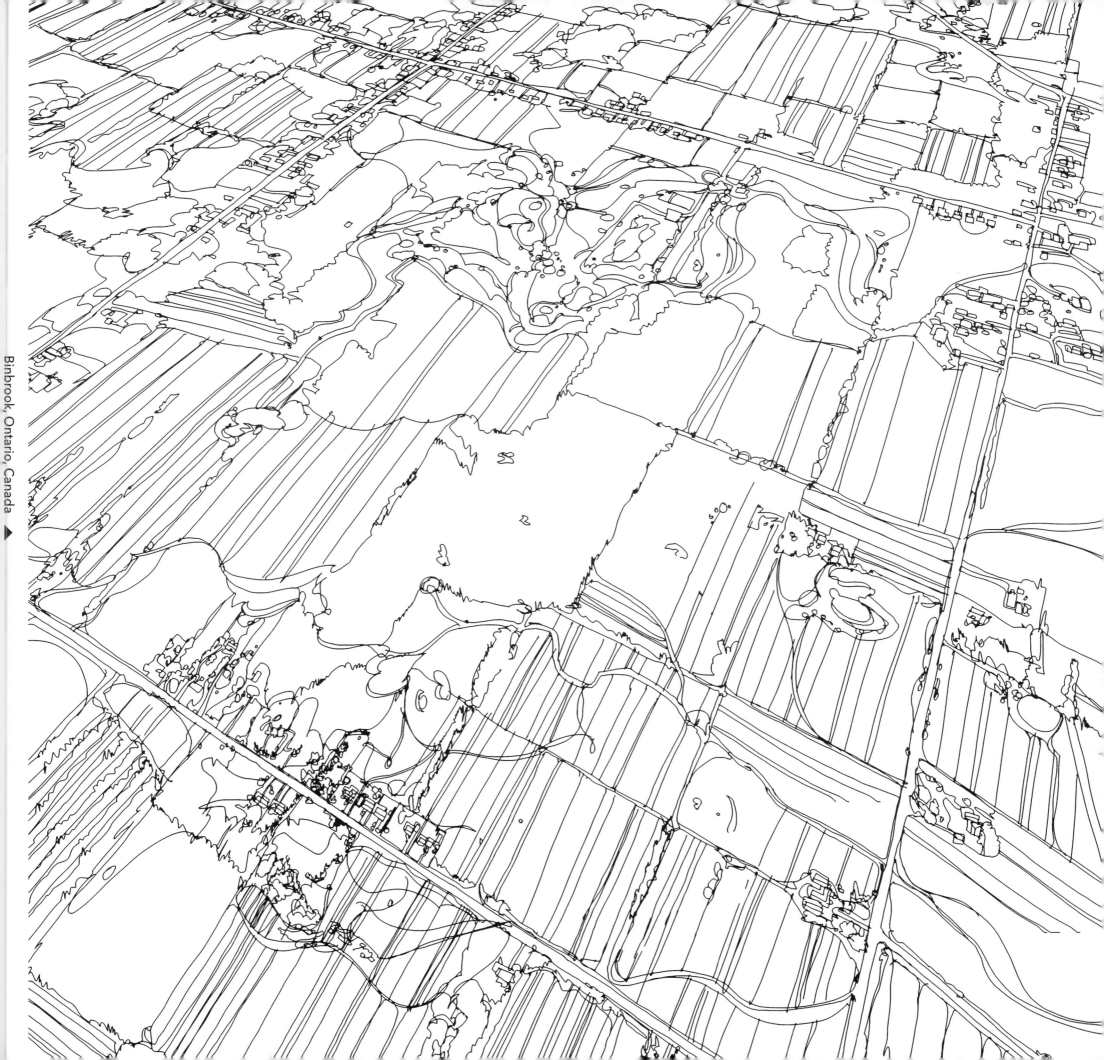

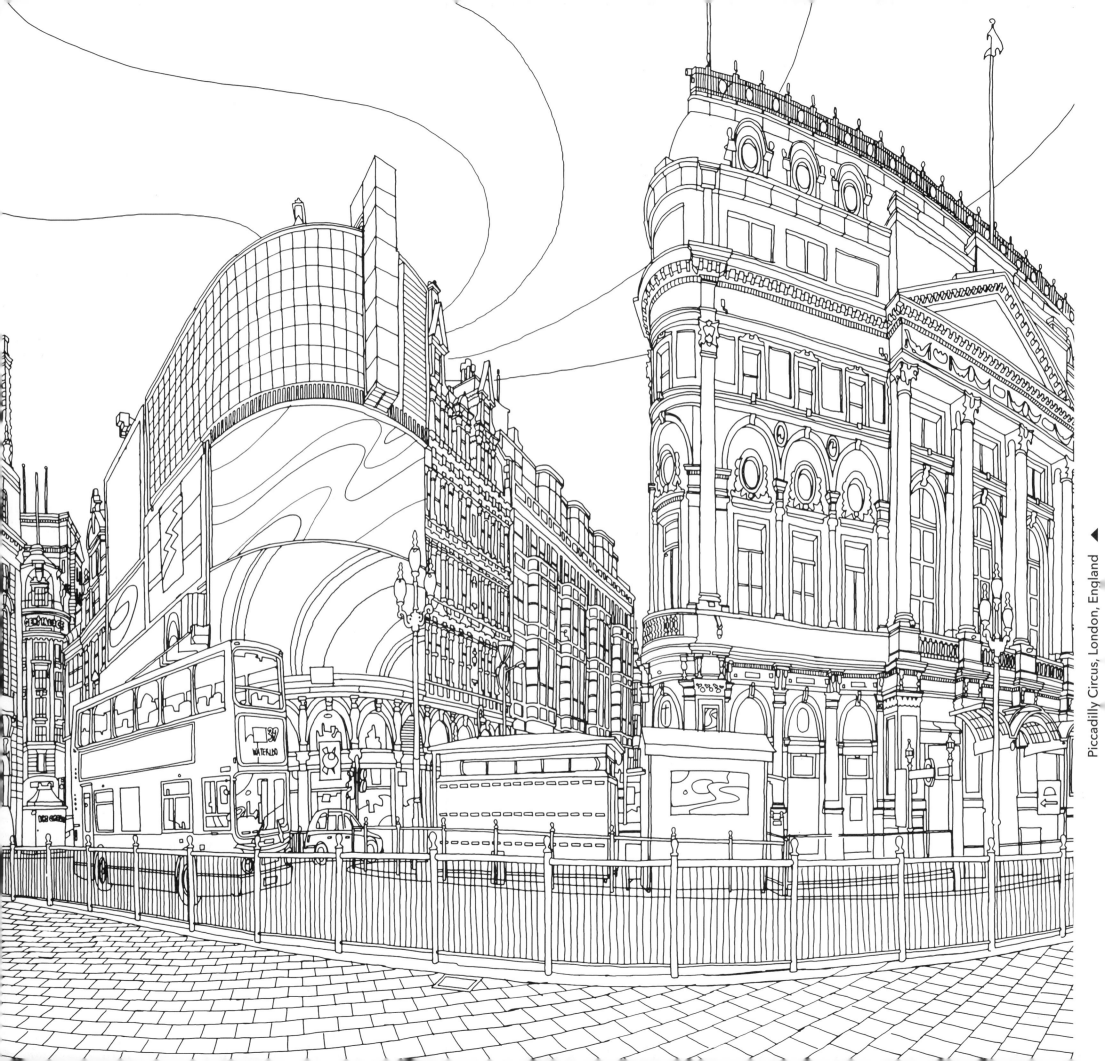

Piccadilly Circus, London, England ◄

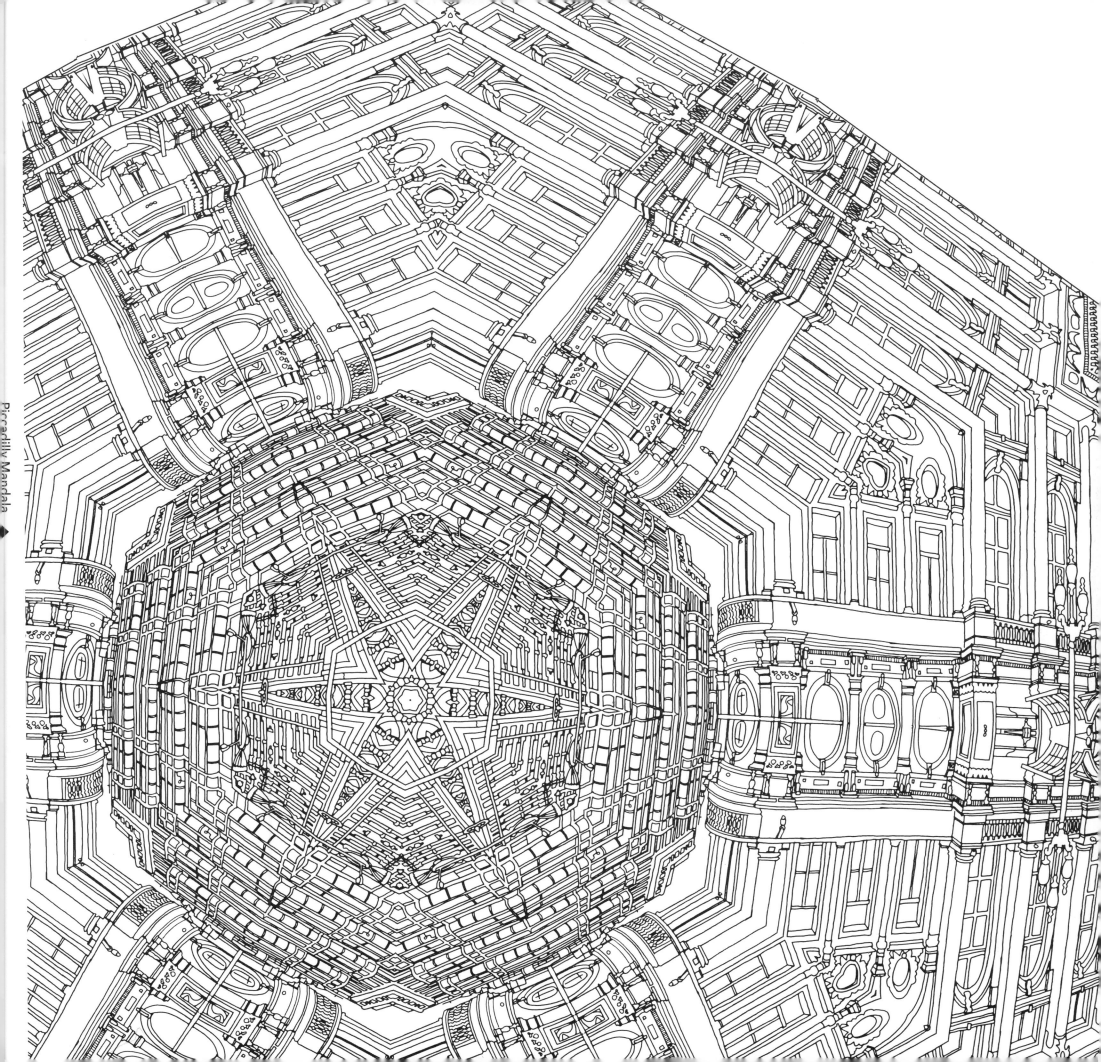

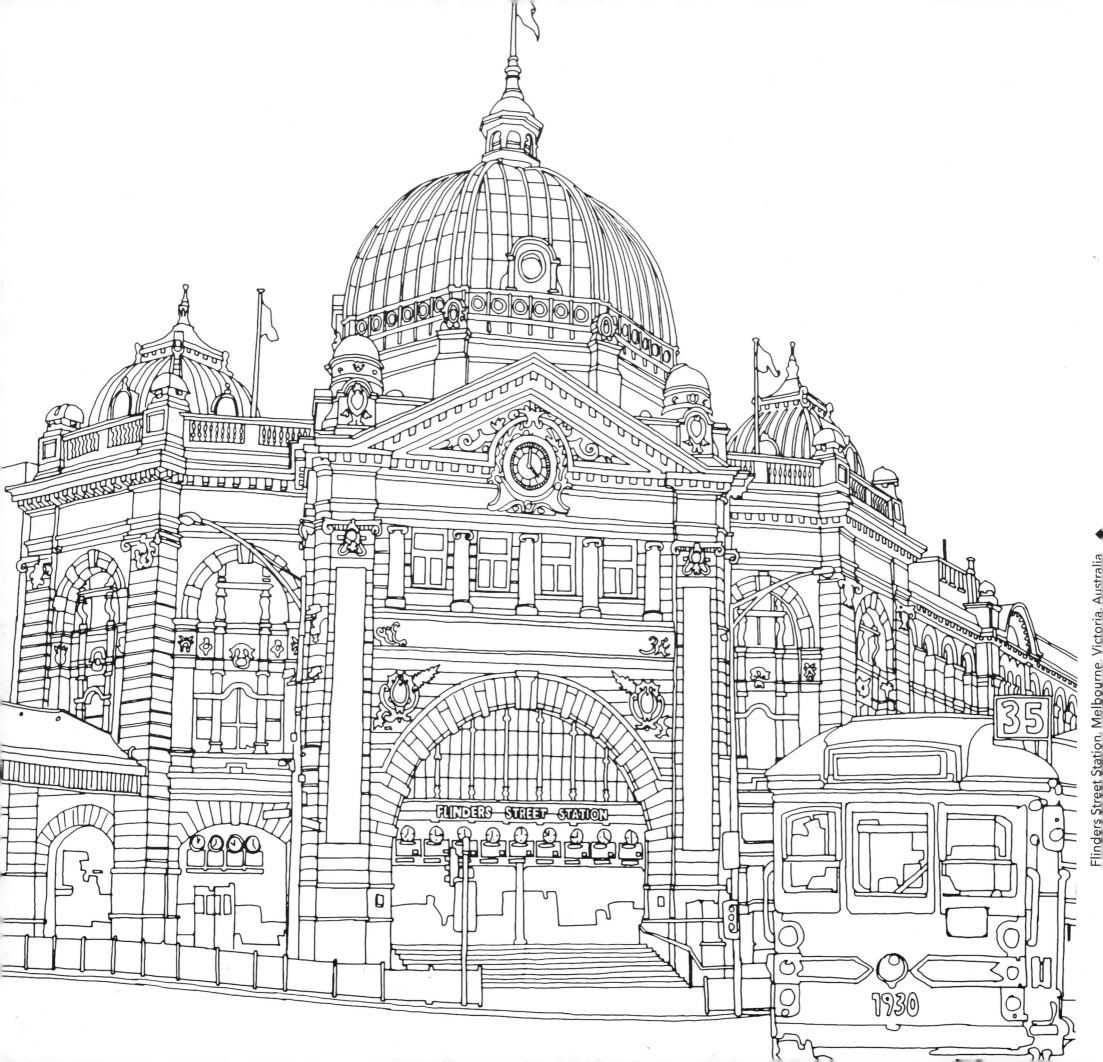

FLINDERS STREET STATION

1930

35

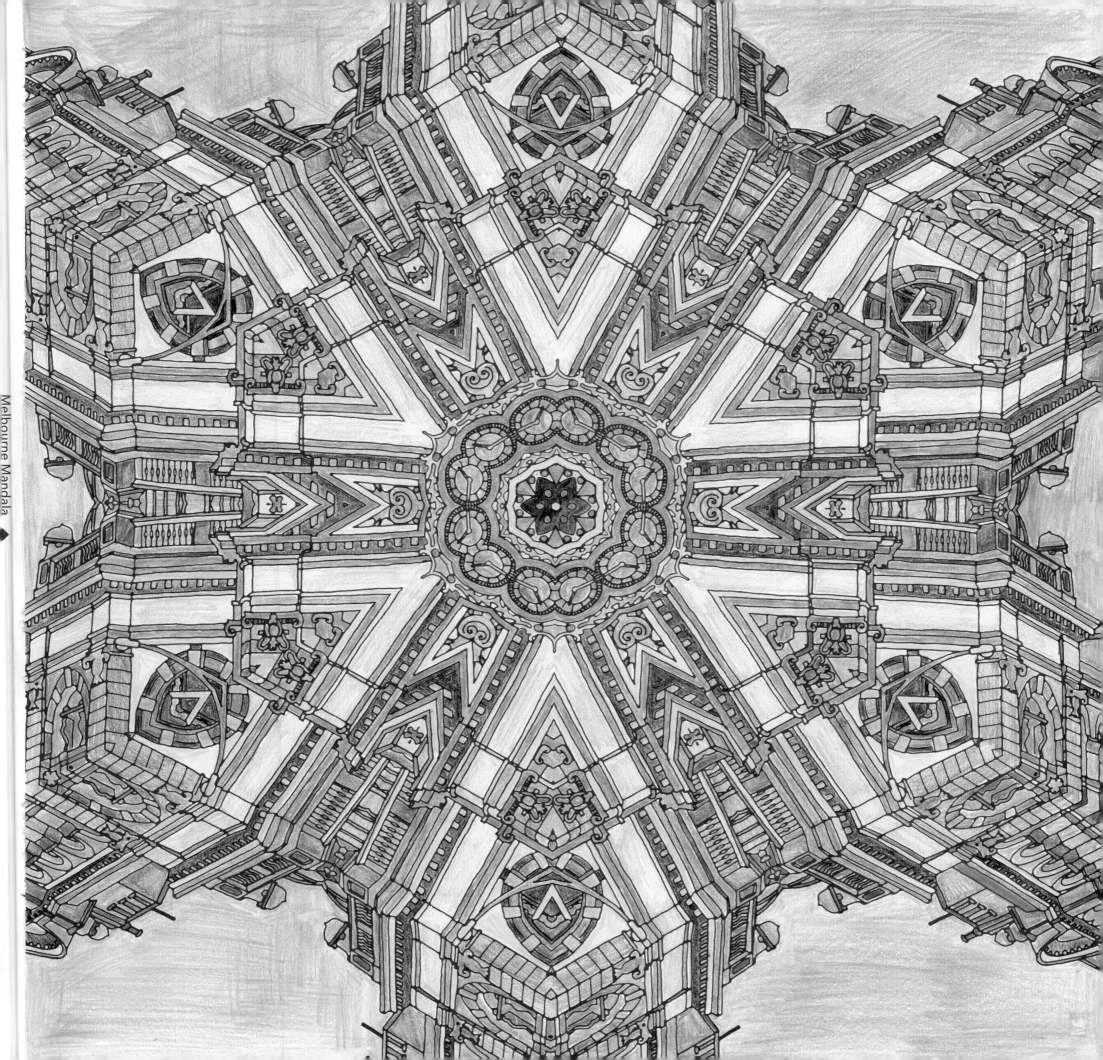

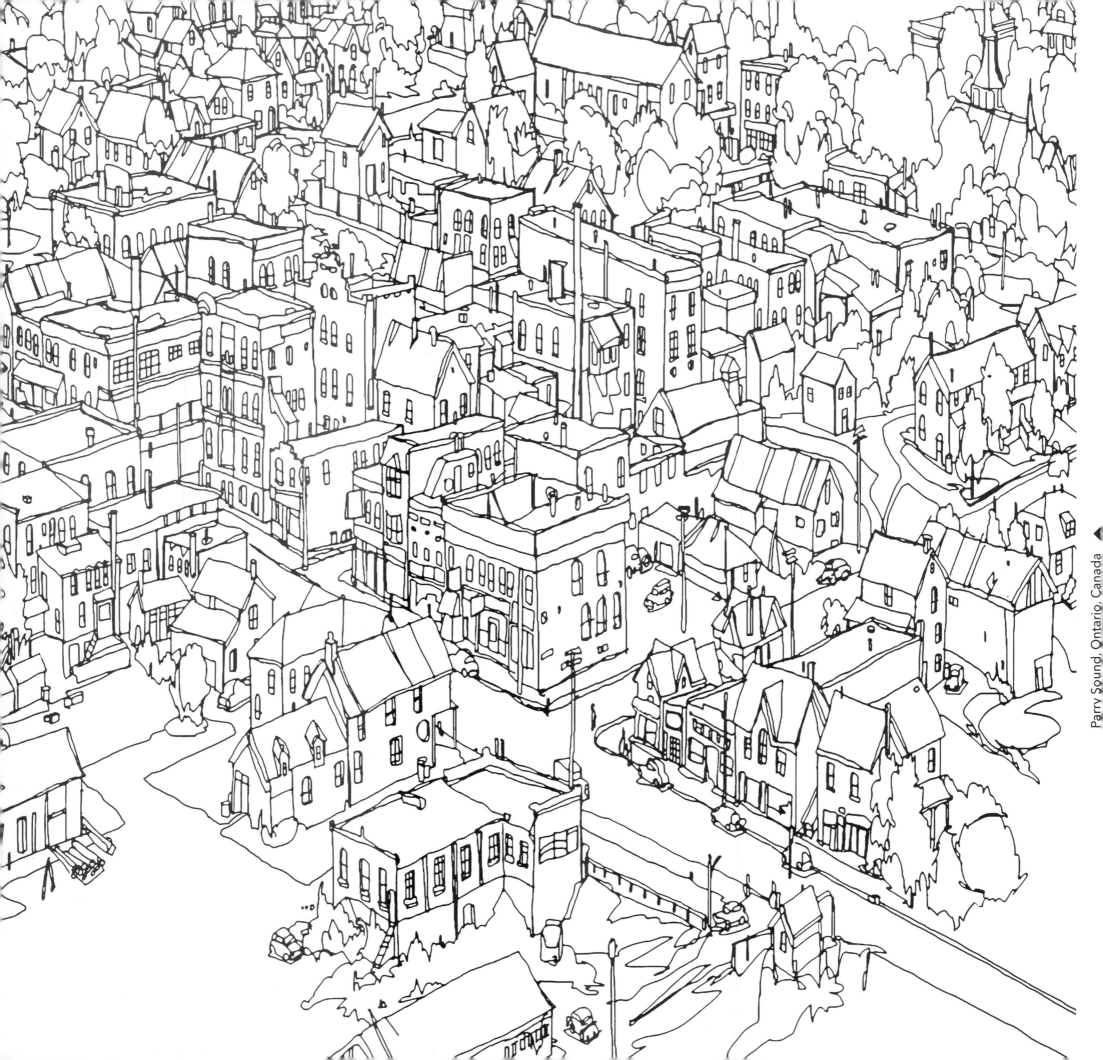

Parry Sound, Ontario, Canada

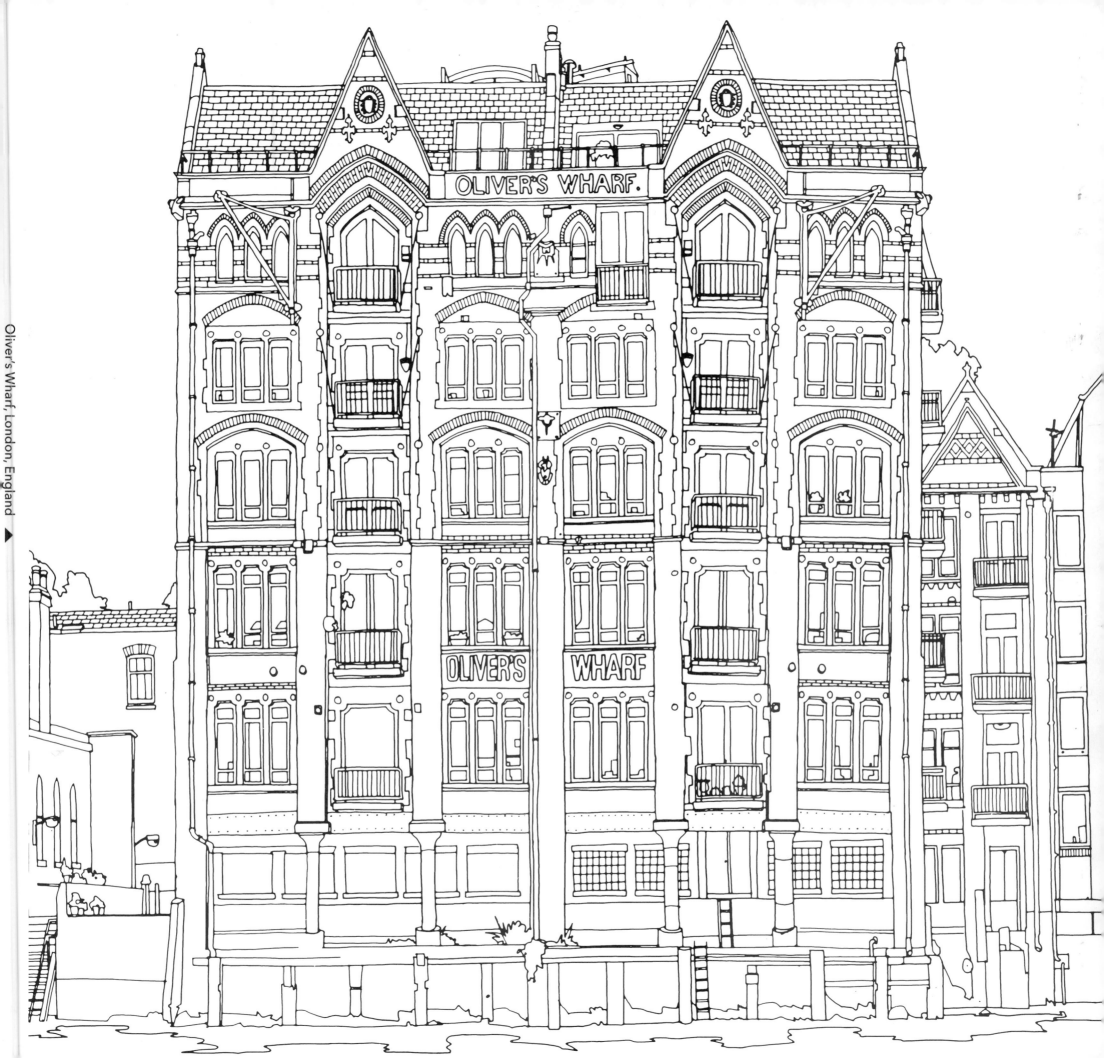

OLIVER'S WHARF.

OLIVER'S WHARF

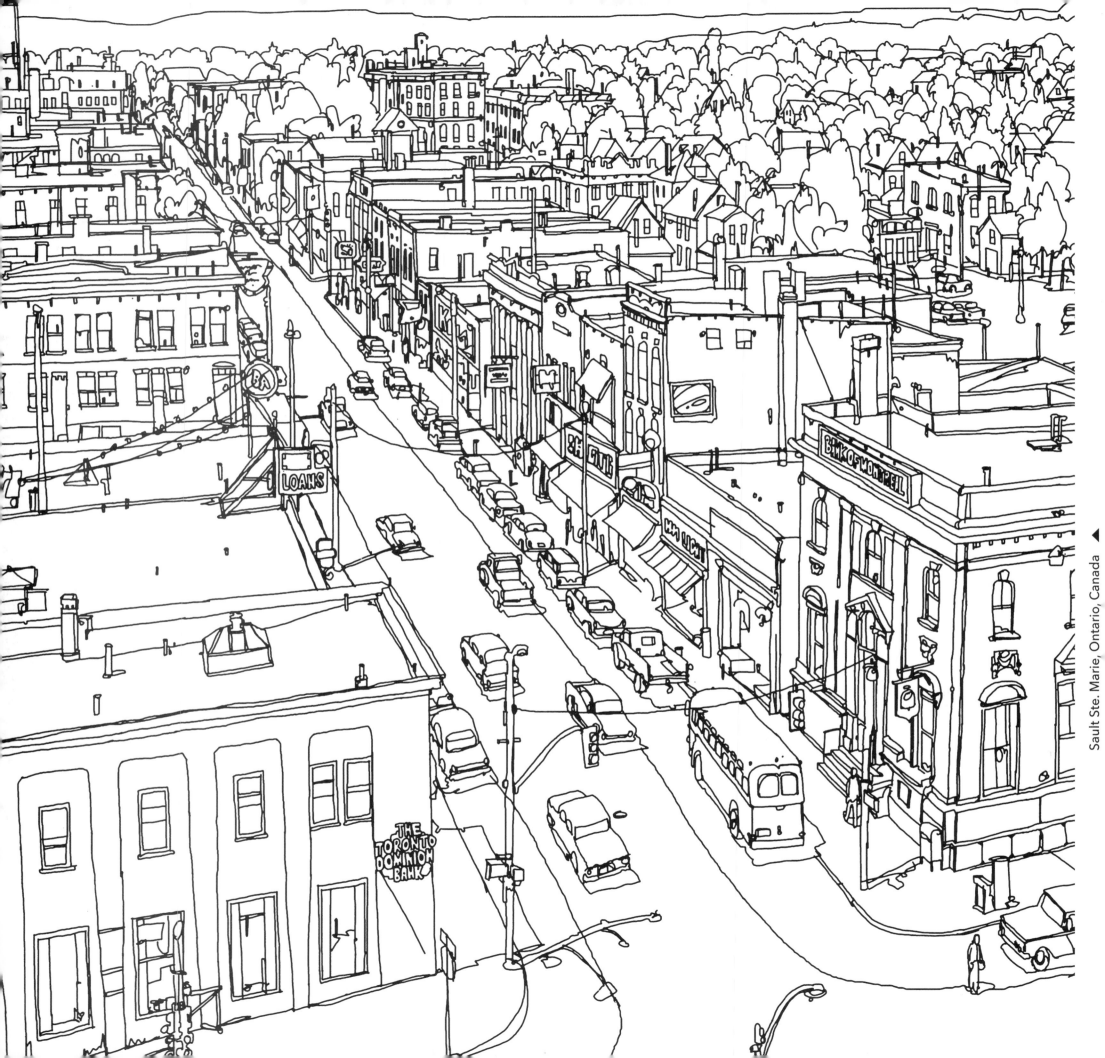

Sault Ste. Marie, Ontario, Canada

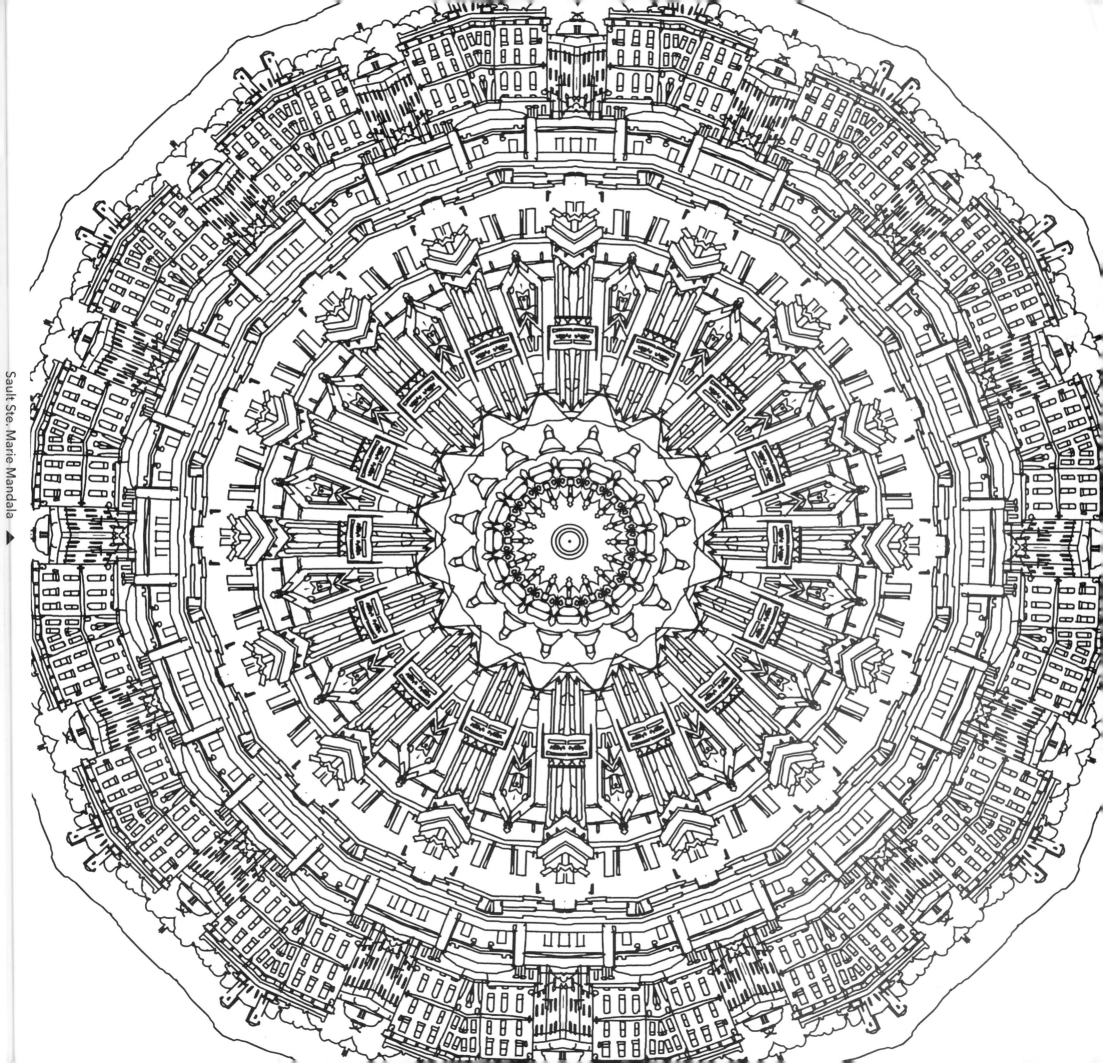

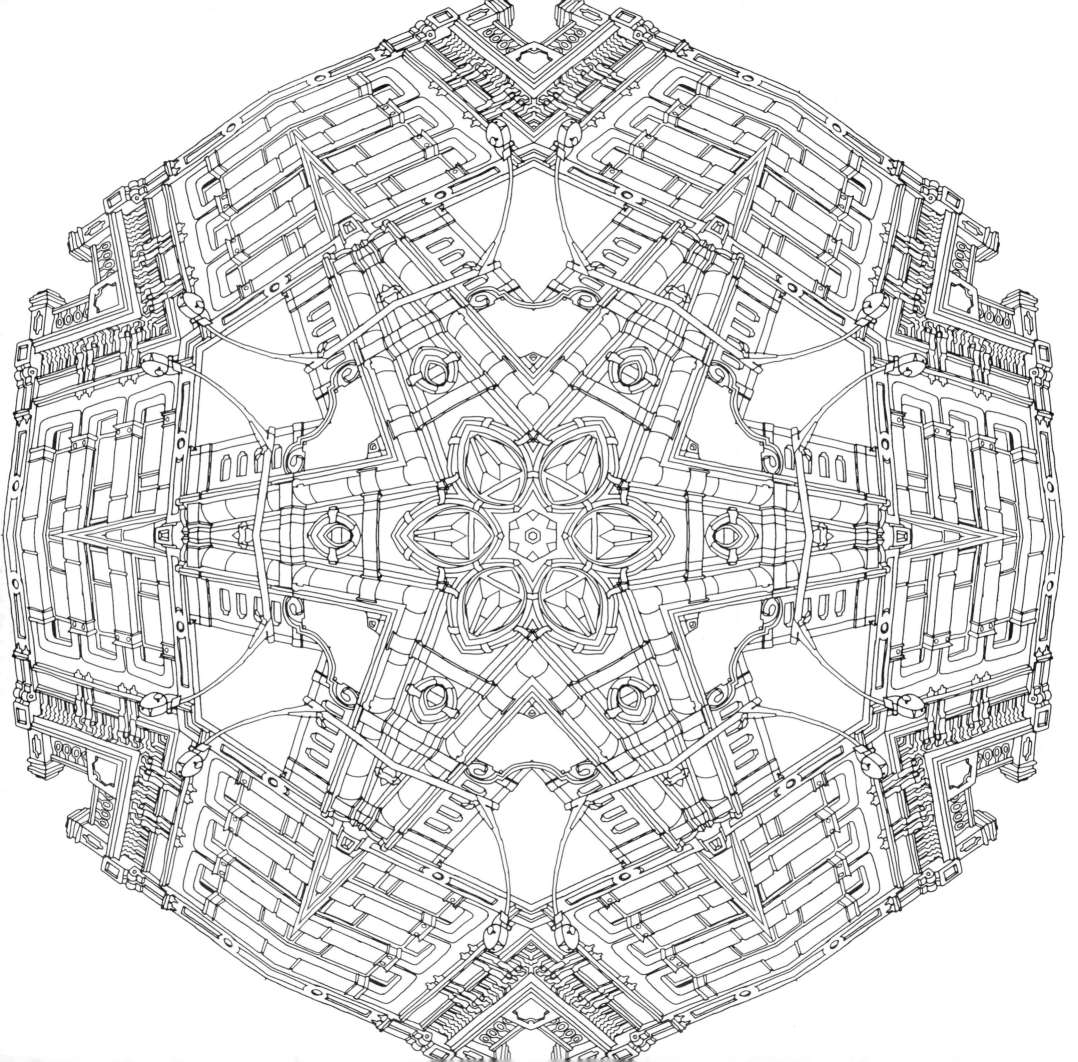

Sydney Mandala ▲

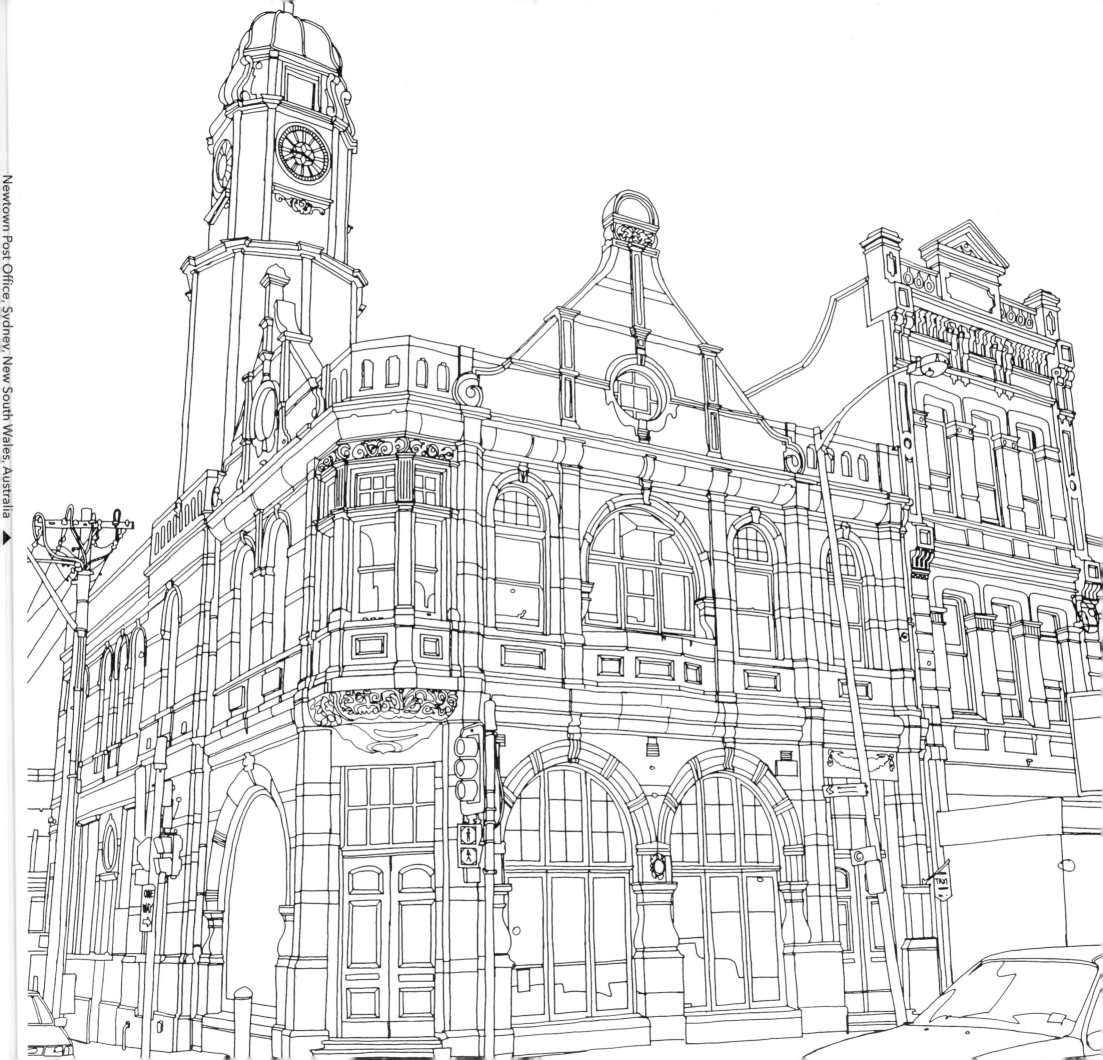

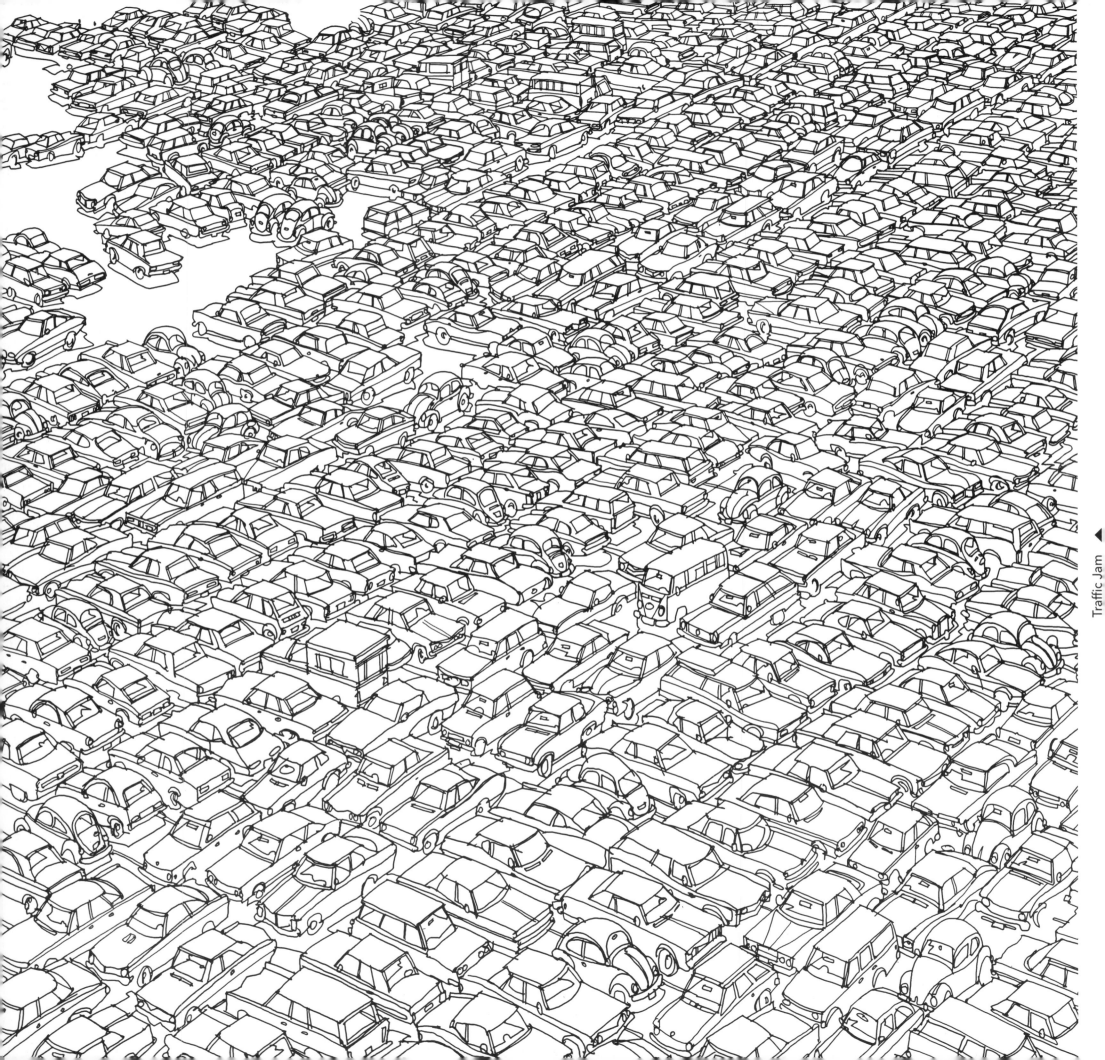

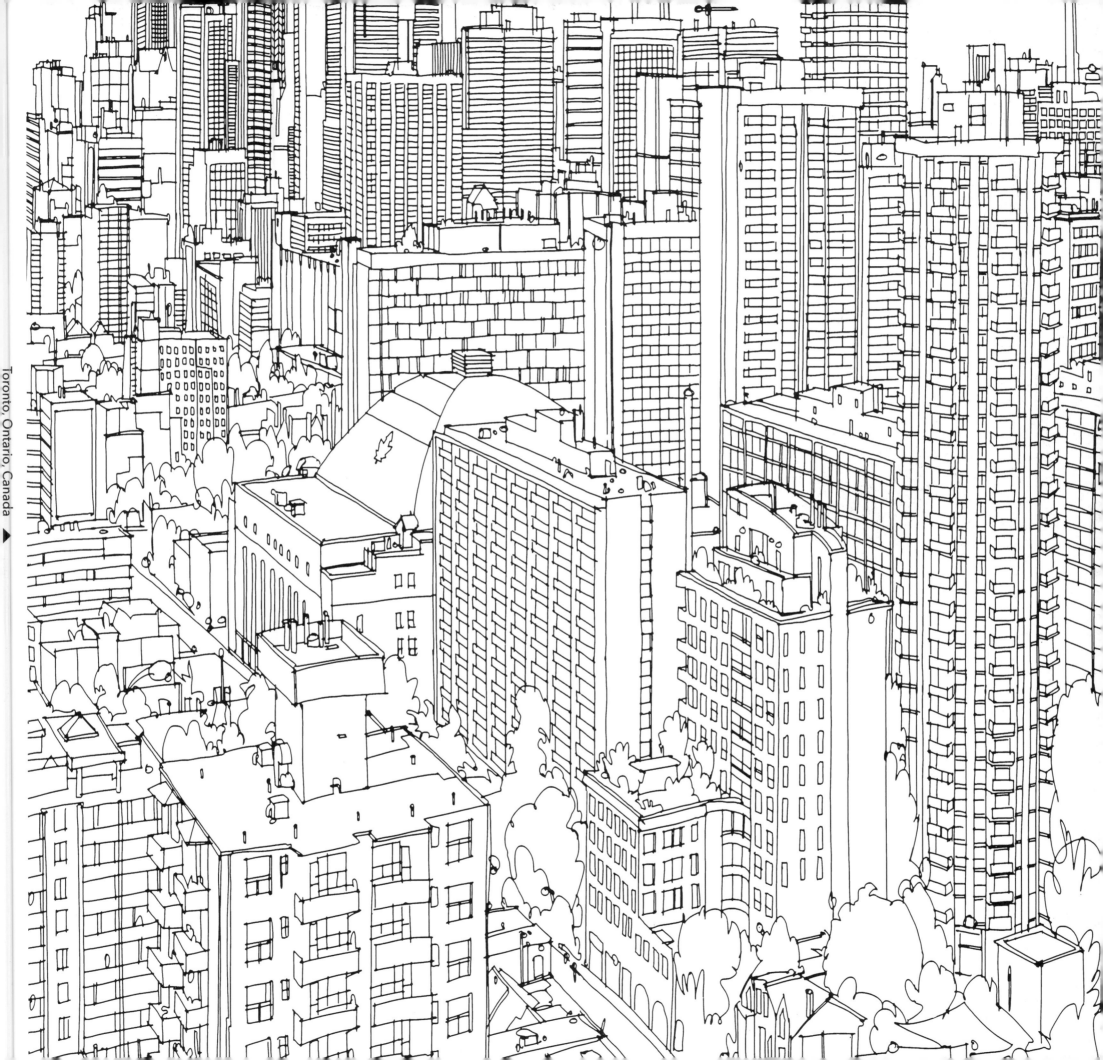

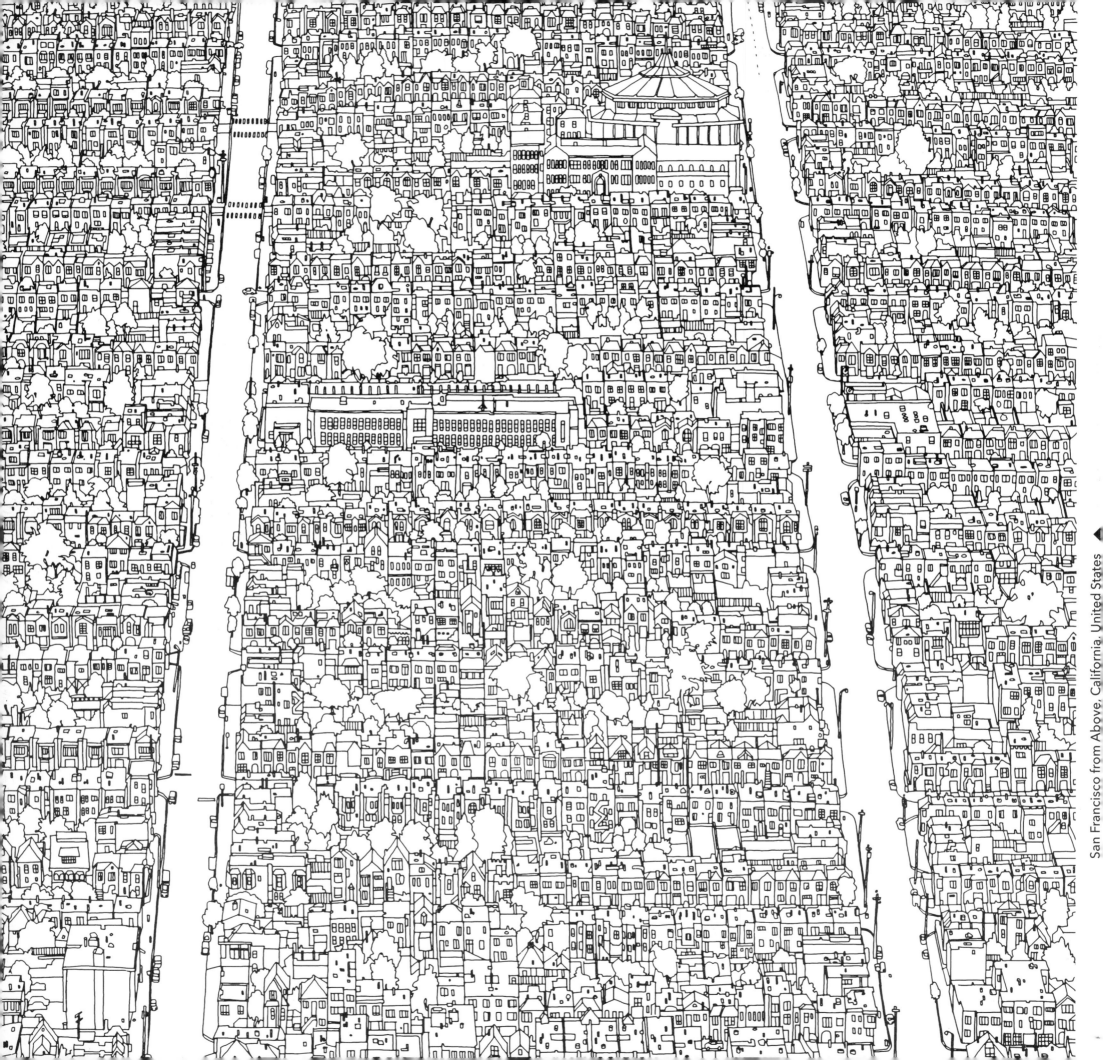

San Francisco from Above, California, United States

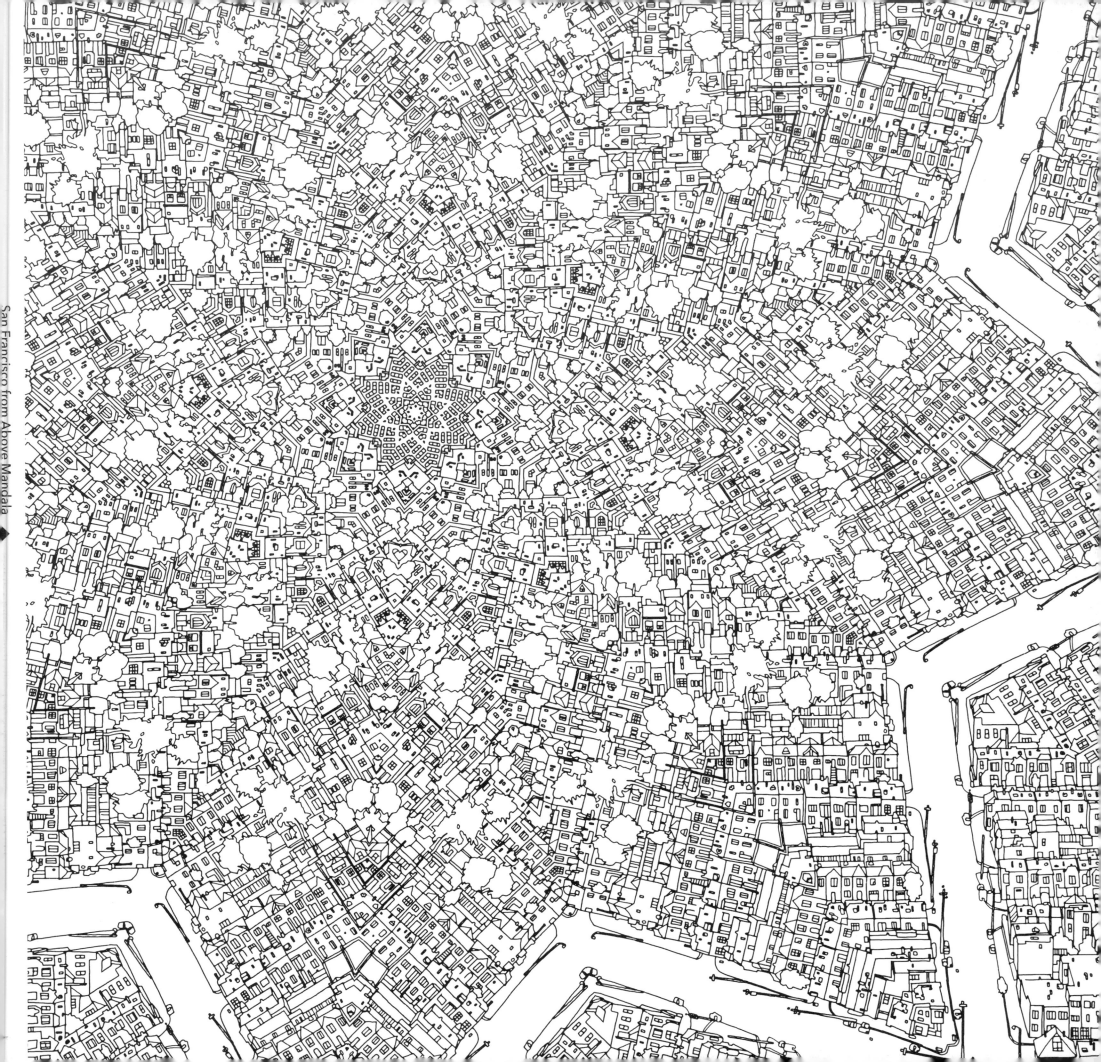

San Francisco from Above Mandala

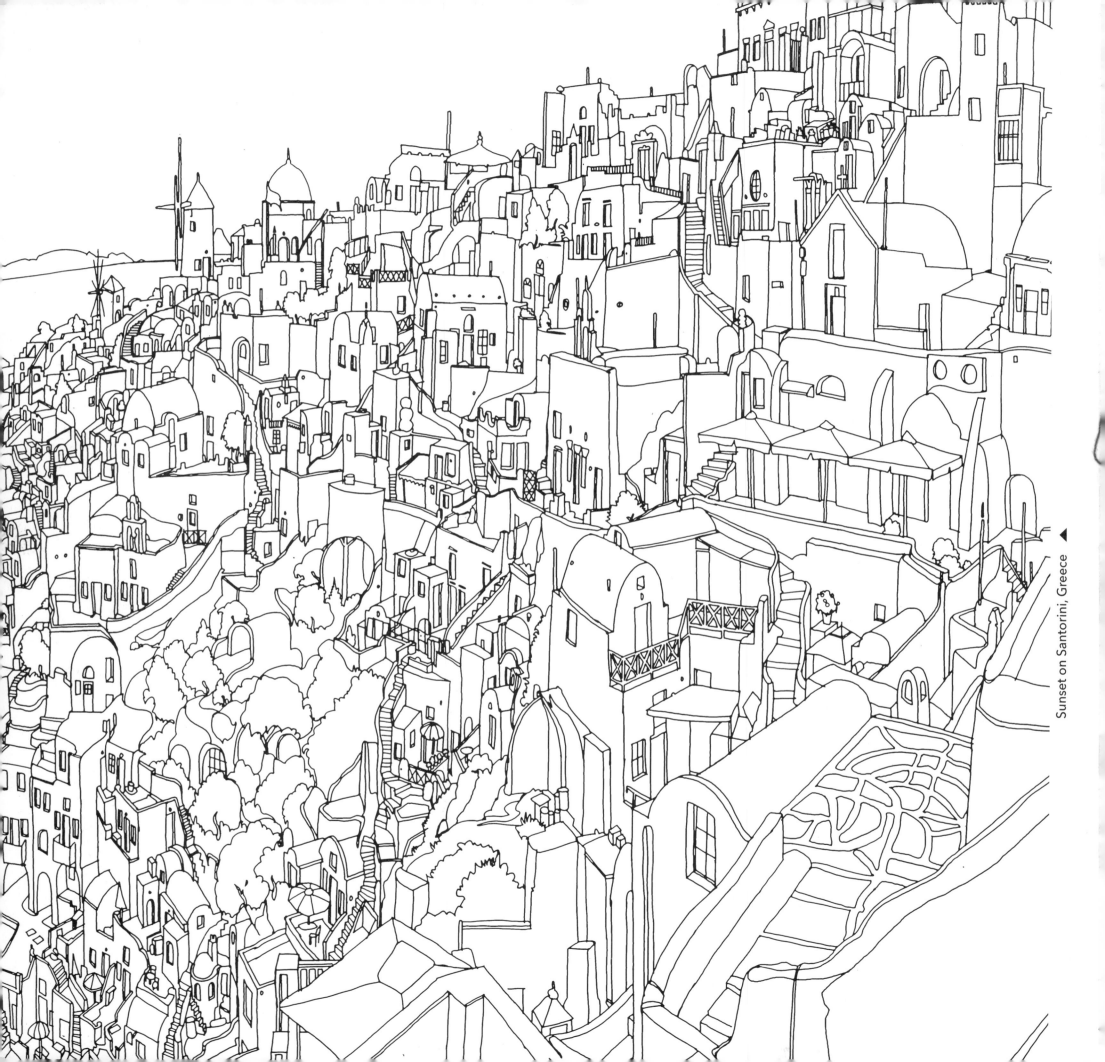

Sunset on Santorini, Greece ◀